IMAGES
of America
FRANKLIN PARK

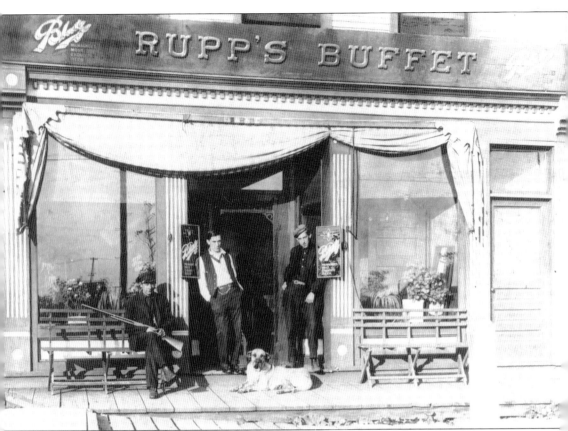

The Rupp family was active in Franklin Park's earliest volunteer fire department. Charles Rupp, standing in the doorway of his family's restaurant at 9660 Franklin Avenue, was fire chief in the early 1900s. The Rupps appear to have been prepared for the hunting season, based upon the shotgun visible in the photograph and the hunting dog lying down on the early wooden sidewalk.

On the cover: Please see above. (Courtesy of Rodger Hammill Studios.)

IMAGES
of America

FRANKLIN PARK

Daniel B. Pritchett and Amanda Helen Schmitt

ARCADIA
PUBLISHING

Published by Arcadia Publishing
Charleston SC, Chicago IL, Portsmouth NH, San Francisco CA

Printed in the United States of America

Library of Congress Catalog Card Number: 2006937666

For all general information contact Arcadia Publishing at:
Telephone 843-853-2070
Fax 843-853-0044
E-mail sales@arcadiapublishing.com
For customer service and orders:
Toll-Free 1-888-313-2665

Visit us on the Internet at www.arcadiapublishing.com

Coauthors Daniel B. Pritchett and Amanda Helen Schmitt are both lifelong residents of Franklin Park and have personally witnessed many of the historical events depicted in this book. Pritchett is currently serving as Franklin Park's village president.

CONTENTS

ACKNOWLEDGMENTS

I would like to thank all of the individuals who contributed photographs and articles to support this publication. Thank you to residents Robert and Lois Michalowski, Ben and John Latoria, Chuck Vogelsang, Mark White, Paul Rubino, Sam Asta, Omar Pritchett, Edith Pfundt, Mitzi Puckner, Robert Steinmetz, Arvis Knutson, Clyde and Jean Dawson, Wallace Felt, Ed Luety, Robert Marshall, Marion and Ken Voss, June Oulund, Margaret Flanagan, Leo Cardelli, and Robert Draper for photographs from your family albums and for your firsthand recollections. I wish to extend a special thank you to Joan Morys and Eric Kemph for their technological support throughout the course of this project and to Mark Johnson and the Franklin Park Library for making the historical room files available to me. I offer my deepest gratitude to the Hammill family for their permission to use many photographs taken by legendary village photographer Rodger Hammill. Finally I wish to express sincere thanks to my family, including my mother, Helen, for opening my eyes up to all types of history; my daughter, Amanda, who spent many childhood vacations visiting museums and battlefields and who helped to make the text in this book more enjoyable; and my wife, Gail, who has embraced all of my endeavors and encouraged me to write down the many pieces of Franklin Park's history that I have accumulated for so long.

—Daniel B. Pritchett
Franklin Park, Illinois (2006)

INTRODUCTION

For hundreds of years, the Potawatomi Native Americans, along with other tribes, occupied an area near the Des Plaines River that would become Franklin Park. The withdrawal of British troops after the War of 1812 and the admission of Illinois as the 21st state in the Union are the two events that opened the area up to early settlers.

William Draper arrived in 1832, at which time he built the first house on the Des Plaines River with assistance from local Native Americans. Over the following 30 years, several German immigrants purchased tracts of land around the area. Most of these 200-to-300-acre lots were located along the river, on early Grand Avenue, and on Mannheim Road, which was then a sectional boundary.

Construction of the area's first railroad in 1867, followed shortly by a second intersecting railroad, caught the attention of a man named Lesser Franklin. Purchasing four farms, Franklin began to plot the community that would bear his name by 1892. Improvements and developments, often financed and built by Franklin's instruction, transformed the once-fertile prairie into a rapidly growing community by the close of the 19th century.

Economic panics of the late 1890s convinced Franklin to convert vacant parcels of land for industrial uses. Industry expanded and flourished during the next century. Vital materials for World War I and World War II were produced in the community.

Several housing developments were created after World War II to accommodate the needs of returning servicemen. Franklin Park's population quadrupled, and it became the third-largest industrial community in Illinois. The village's proximity to O'Hare International Airport and to highway and railway access keeps it healthy and growing today.

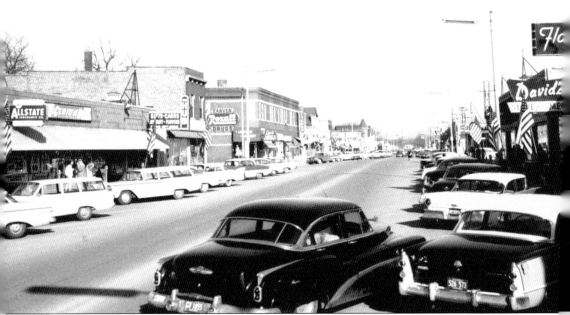

This 1962 photograph of Franklin Avenue shows cars parked at storefronts on the 9700 block. The shops here include Milton's Shoes, David's Men's Wear, Klauk's Dime Store, Pinocchio's Restaurant, Farver's Drugstore, the Hub Gifts and Records Shop, Certified Grocery, and Allstate Insurance. The flags shown mounted to parking meters were always displayed on legal holidays.

One

NATIVE AMERICANS AND EARLY SETTLERS

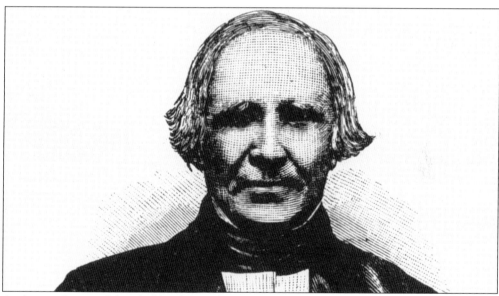

At the conclusion of the Blackhawk War (1832), five million acres of Native American land were ceded to the United States according to the Treaty of 1829, signed at Prairie du Chien, Wisconsin. Two local Native Americans were rewarded land for their services on behalf of white settlers. Claude LaFramboise received one section of land along the Des Plaines River, and Chief Alexander Robinson (Che-Che-Pin-Qua), pictured here, received two sections (1,280 acres). Robinson had come to the aid of Chicago's first European settlers, the Kinzies, at the Fort Dearborn Massacre (1812) and also assisted with the treaty, which was officially signed on July 29, 1829. More portions of the ceded land were purchased over the following 40 years. Today those properties comprise much of Schiller Park and the north end of Franklin Park. Robinson passed away at his farm on East River Road and Lawrence Avenue on April 22, 1872. He was 110 years old. Today a large stone marks the graves of Robinson's family members.

Alexander Robinson married Catherine Chevalier in 1820. Together the couple had seven children. After her death on August 7, 1860, Catherine was buried along the banks of the Des Plaines River beside four of her children who had died as infants. Alexander divided his remaining property among his sons, John and David, and his daughter, Margaret. This Cook County tax receipt, dated February 6, 1858, was for David's 230 acres in Leyden Township. The acres were taxed at about 17¢ apiece.

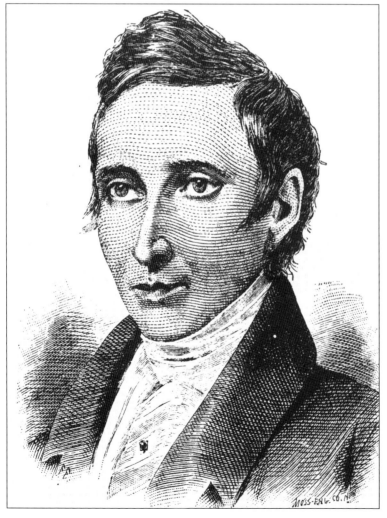

Franklin Park is located within Cook County. Born in Kentucky, Daniel Pope Cook was a lawyer and a newspaper publisher. He encouraged territorial legislators to petition Congress for statehood. On December 3, 1818, Pres. James Monroe signed the act of admission by which Illinois became the 21st state in the Union. Cook went on to become Illinois' first attorney general and second United States Congressman, winning support for the important Illinois-Michigan Canal. A lifetime of poor health led to Cook's early demise at the age of 33. Cook County was named in his honor in 1831.

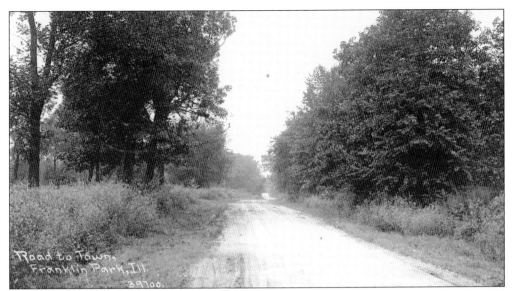

The road pictured in this early postcard, titled "Road to Town, Franklin Park, Illinois," could easily be Grand Avenue, Mannheim Road, or River Road. Nearly all of Franklin Park's first settlers obtained properties adjacent to these early roads. River Road was an ancient Native American trail, as it followed alongside the Des Plaines River. When a toll bridge was constructed over the river, Grand Avenue became a route for stagecoaches, extending from Chicago to Elgin. Mannheim Road ran across Franklin Park's first railroad tracks, making it a popular area for early commercial development.

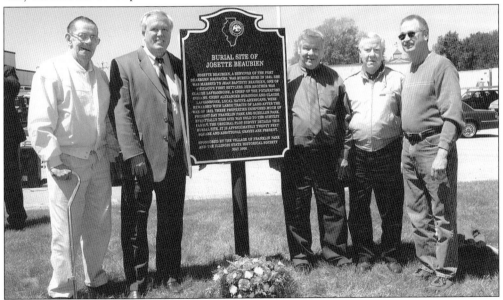

State Rep. Mark Beaubien (to the immediate left of the sign), descendant of Josette LaFramboise Beaubien, stands with Allan, Robert, Harold, and Bob Schultz (from left to right) at his ancestor's grave site. While alive, Josette purchased land from her brother, Claude, which had been awarded to him after the War of 1812. The property was sold to the Schultz family after her death in 1845. Josette married Jean Baptiste Beaubien in 1813, and the couple raised their family of 13 children close to the site of her brother's property.

11

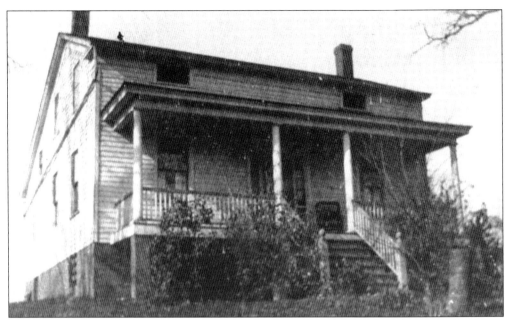

The area's first settler of European descent was William Draper. In 1833, he built the first house in what would become Franklin Park. Aided by local Native Americans, Draper constructed the above home with wood that was processed from the trees on his tract of land and plaster that was mixed with sand from the Des Plaines River adjacent to his property. The house was razed in the 1950s.

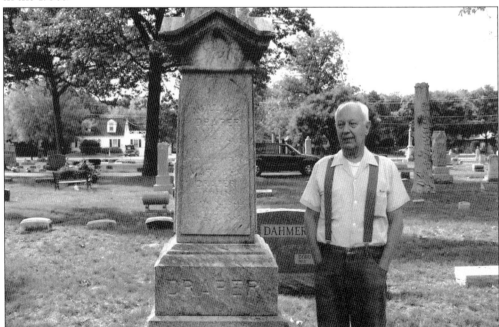

Robert Draper stands beside his great-grandfather William Draper's grave marker at Town of Maine Cemetery. Robert's boyhood home at 2920 Maple Street was built by Hiram Draper, one of Franklin Park's early mayors, in 1883. Robert Draper purchased the family home sometime in the 1980s. He restored it back to its original condition, even doing extensive landscaping work at the site.

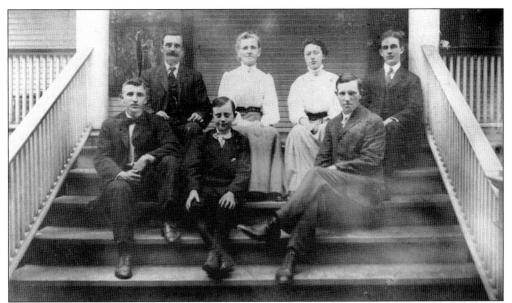

Hiram and Louisa Draper (top left) sit with their children on the 400 acres they purchased at Maple Street and Pacific Avenue in 1890. Elected to the first village board as a trustee in 1892, Hiram Draper eventually became village president. He served many one-year terms in office. Often seen driving a horse and buggy around town, Hiram ironically died after he fell from a wagon and broke his neck in 1919.

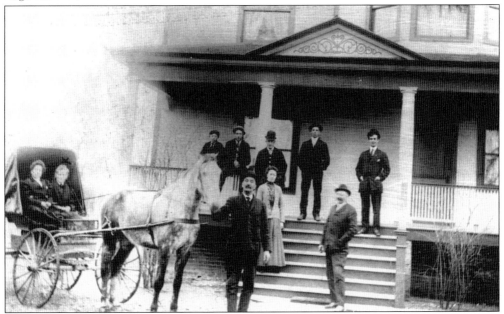

Hiram Draper, Franklin Park's third village president, is shown here holding the horse's reins. He built this beautiful home at 2910 Maple Street as a wedding gift to his daughter Mary and his son-in-law Walter Schutt in 1905. The house had running water (manually supped to a tank in the attic) and a telephone (No. 32W) connected to the switchboard above the State Bank of Franklin Park at Calwagner Street and Franklin Avenue. Walter Schutt was one of the original founders of Leyden High School.

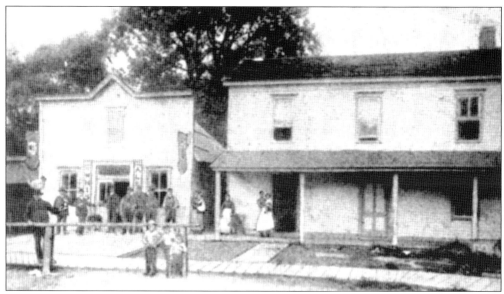

Leyden Township was organized on April 2, 1850. M. L. Dunlap was the first person elected to the position of supervisor in the township. David Everett purchased property along the Des Plaines River near Grand Avenue 17 years prior to Leyden Township's first election. The construction of a log house, the hotel (right), and the post office shown here was first named Cazenovia by the Spencer family. A subsequent postmaster changed its name to Leyden Center. By 1850, the area was simply called Leyden.

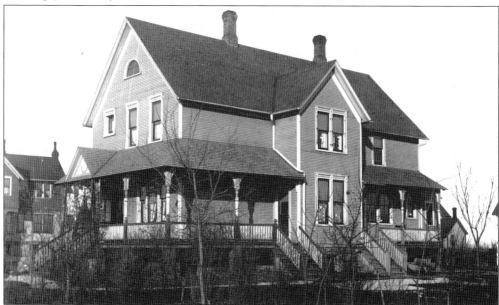

Village of Franklin Park employees once referred to this old residence as the Delta House. Located across the street from the police station, it was used to house village offices for 15 years after Franklin Park purchased it from Edward and Lois Kob in 1978. Dora Violet Martens bought the house from Henry C. and Elizabeth Martens in 1893 for $2,000. Dora played organ at the Methodist church from 1898 to 1922. She also sold her house in 1922 for $3,500. She passed away in 1926 and was buried at Graceland Cemetery in Chicago.

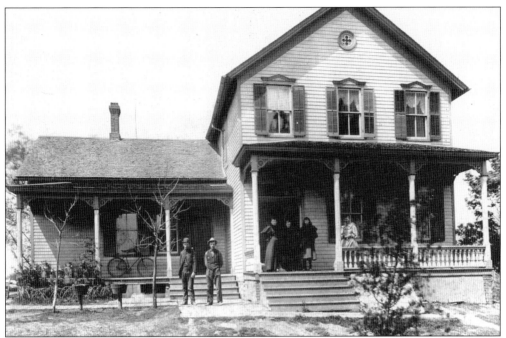

John Schultz, born in Germany in 1837, purchased three tracts of land on River Road between 1864 and 1870. In 1879, he bought 13 additional acres in the Robinson Road area, extending east across the Des Plaines River, for $26. This acreage contained the burial site of Josette LaFramboise Beaubien, a survivor of the Fort Dearborn Massacre of 1812 and the sister of Claude LaFramboise. Schultz and his wife, Dorothea, raised their nine children in this farmhouse at River Road and King Street. The house was eventually moved and razed in the 1960s to create room for Robinson Crusoe Park.

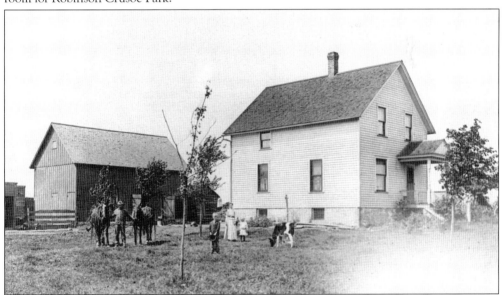

Constructed on a foundation of bricks salvaged from the Chicago fire, this was the second house built on the rear of the Schultz farm, a long tract of land fronting on the Des Plaines River. Schultz family descendants continue to occupy the house today.

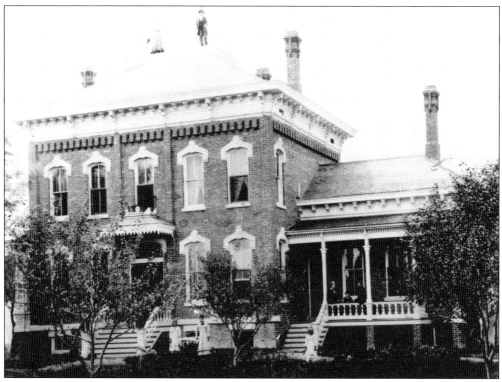

Sophia and Christian Schierhorn settled along the Des Plaines River around present-day Belmont Avenue. After constructing their first dwelling, a log cabin, they built this beautiful home facing south, approximately a quarter mile west of the river. Vivid descriptions indicate that the intricate interior had murals painted on the walls and ceilings, adding to its stately appearance.

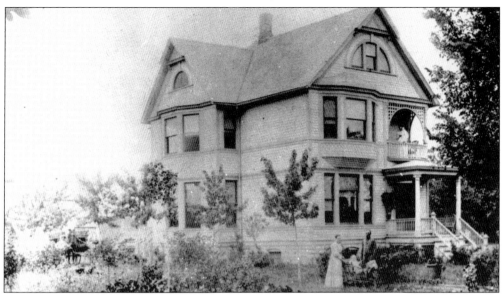

One of several buildings constructed on the Schierhorn farm was this beautiful, two-story frame home overlooking the river. Henry Schierhorn built it in 1890. Other portions of the farm were used for the construction of the Soo Line Railroad's tracks and for the extension of Belmont Avenue into Franklin Park from the Des Plaines River in 1927. Farming eventually gave way to industrial development, and Roger Schierhorn began operating a trucking business along River Road. Many houses and other buildings were constructed on the farm over the years. Today only the residence at 3300 River Road remains.

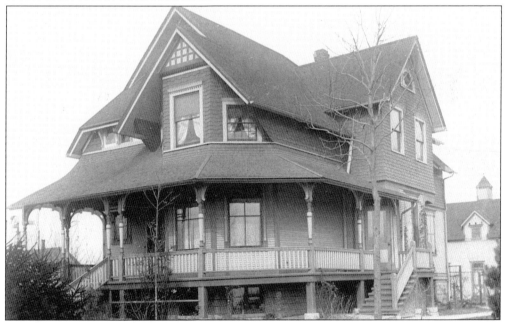

This home was built for Valentine Ruh in 1892 on a tract of land owned by Dr. Clayton Boyer. The property was granted to Boyer by the United States government for his services in the War of 1812. In 1938, Thomas and Irma Tiedemann purchased the home and moved their funeral business into it from Franklin Avenue.

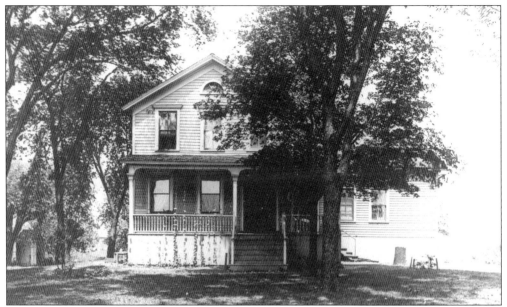

Charles and Frederika Martens arrived in America from Hamburg, Germany, on October 4, 1847, and purchased 120 acres of land along Grand Avenue soon after. It was on this land that they built the home shown here. It originally faced Grand Avenue, in the middle of what would become Washington Street. The house was eventually broken into three sections and moved. One section is now the residence that sits at 2813 Washington Street. One of their sons, Charles Jr., became Franklin Park's first mayor, and another son, John, was a postmaster and owned a general store in town.

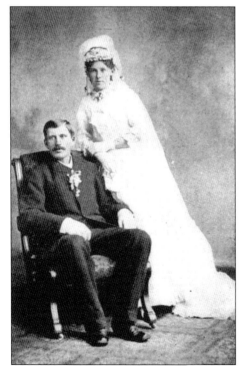

Charles Martens Jr., Franklin Park's first village president, is pictured here with his wife, Louisa, on their wedding day. Louisa was the daughter of an 1849 gold miner named John Adam Popp. She lived to the age of 103.

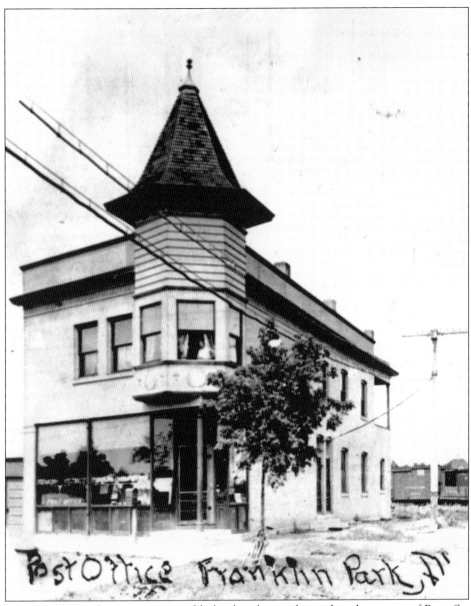

One of Franklin Park's most recognizable landmarks was located at the corner of Rose Street and Franklin Avenue for 93 years. The first building that stood here, erected in the early 1890s, housed John Martens's store and the post office. The first village board meeting took place there, as did the earliest Methodist church services. A fire destroyed the original building, and the structure pictured here was built in 1913. Over the years, numerous tenants used this building, including the Franklin Park Garage, the Eagle's Nest Youth Center, Cripes Sheet Metal, and Lutz Jewelers. After the Cripes family purchased the building, daughter Vivian and her husband, Daniel Lutz, opened a jewelry store in 1947. Lutz, a World War II veteran and watchmaker from Saginaw, Michigan, also serviced small appliances, repaired aircraft instruments, and performed monthly inspections of railroad personnel's watches. The structure was razed in 2006, but the turret on the corner was removed and will hopefully be reused on another piece of architecture in town.

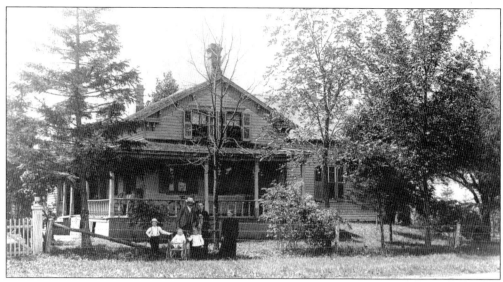

Born on March 1, 1815, John Adam Popp came to Chicago in 1847. In 1849, he headed for the California gold fields. Popp returned to the Franklin Park area sometime after the Civil War. Trading in gold dust that he had collected during his years in California, he purchased 160 acres of land along Grand Avenue, stretching from Rose Street to Ruby Street. Popp fondly recalled telling his grandchildren about reading a newspaper from the light of the Chicago fire. He built his first home, pictured here, in 1871. The house was moved farther south in 1900 to accommodate a larger home that was eventually converted into a series of restaurants including Lindy's, Bino's, the Gallery, and Sneakers Sports Bar. Popp and his wife, Elizabeth, had three children, and he passed away on November 26, 1898.

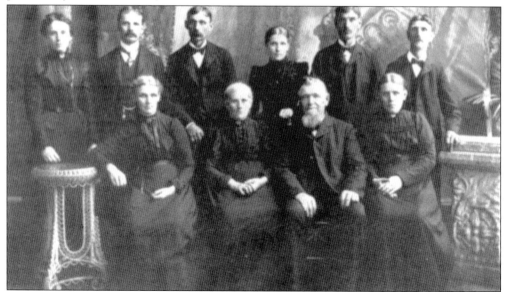

Ernst and Louise Pflug (née Meyer) immigrated to America from Lodingsen, Germany, in 1847. The Pflug family, consisting of seven brothers and sisters, farmed in two areas. One of their farms was located east of the Des Plaines River in River Grove. This area eventually became St. Joseph's Cemetery. The Pflugs built their first home on acreage northwest of Rose Street and Grand Avenue.

Ernst Pflug's first farmhouse, apparently vacated in this undated photograph, faced Grand Avenue and stood just east of where Hester Junior High School stands today. Lesser Franklin purchased the property in the late 1880s as part of his plan to develop a new town. After selling their farm, the Pflugs relocated further south, east of Mannheim Road and north of Fullerton Avenue. In the second photograph of the old farm, the house is on the far left with an adjacent outhouse. The long building in the center is a machine shed. A wagon sits alongside the chicken coop, corncrib, barn, and silo. Today only the house remains at 2524 Dora Street.

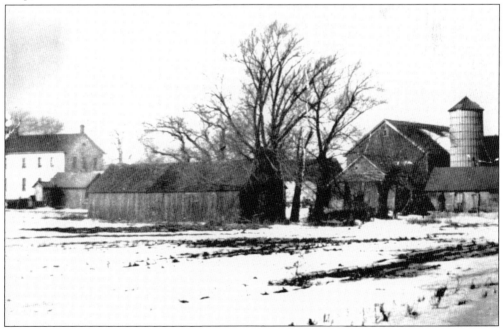

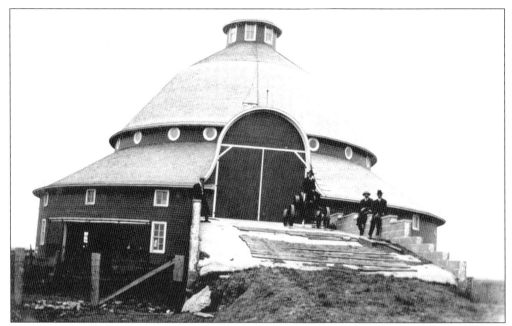

The round barns popular during the 1800s and early 1900s were considered more economical structures than conventional rectangular-shaped barns. Livestock's feeding troughs, facing into the center, allowed easy feeding from above. Wagons could travel around the inside without having to turn. The barn pictured here was located on the Didier farm, south of Grand Avenue. Local farming families gathered here for celebrations like square-dancing parties, church picnics, and weddings.

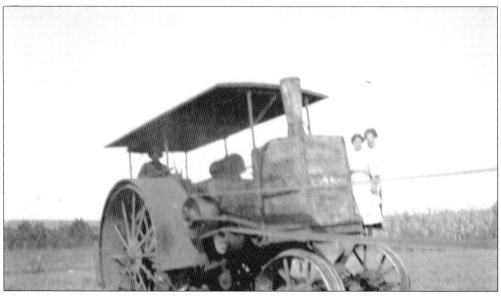

This early tractor was used to cultivate the farming area south of Grand Avenue. The unidentified people onboard were probably members of the Didier family. The belt extending from the tractor was used to power auxiliary pumps and sawing equipment in the field.

Friederich Freie built this home at 10033 Schiller Boulevard after coming to Franklin Park from Germany sometime after 1850. His daughter Anna Adelheid married Frederick Hilgenfeld on May 3, 1867. Hilgenfeld had been wounded and discharged from the Civil War on October 29, 1864. The couple moved to Falls City, Nebraska, a few years after they married. Freie sold his farm to Lesser Franklin in 1890 and built a new home at the northwest corner of Belmont Avenue and Mannheim Road.

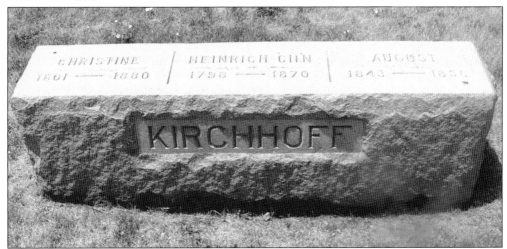

Henry Kirchhoff Sr., born on February 20, 1796, in Germany, came to America as part of a large migration during the 1840s. While revolutions erupted across Europe, Henry and Christine Kirchhoff sailed away with their eight children. After arriving in New York, the Kirchhoff family quickly took off for the Midwest and arrived to Leyden Township in October 1846. Henry Sr. built a 20-foot-by-36-foot house on 10 acres of land and purchased 80 additional acres near Grand Avenue. Kirchhoff spent his last days with his son Henry Jr. He was buried at St. John's Cemetery, presently located inside O'Hare Field.

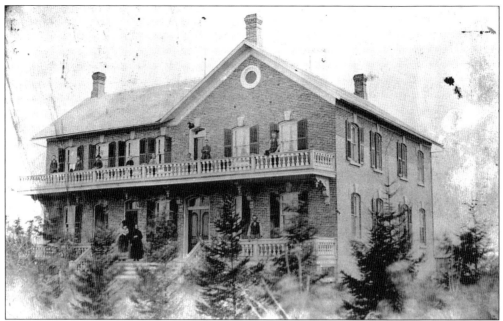

Henry Kirchhoff Jr. remained under his parents' roof until he reached age 25. He purchased 240 acres of land from the State Agricultural College and eventually also bought his father's 80 acres. In 1873, he built this beautiful redbrick home for his wife, Mary Ann Franzen, and their family of 12 children. He sold 280 acres of his land to Lesser Franklin 17 years later and moved to the Mannheim area. Kirchhoff passed away in his daughter Mary's home in June 1908 and was buried at St. Johannes Cemetery, now located inside O'Hare Field.

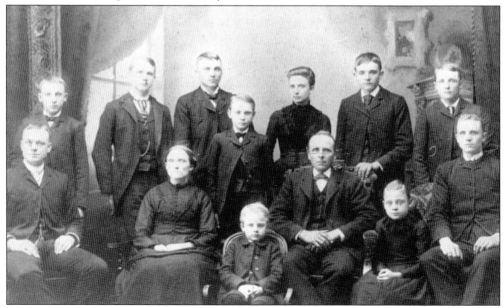

The Kirchhoff family is shown here posing for a family portrait in their home at 10067 Franklin Avenue. Seen here are, from left to right, (first row) Henry, mother Mary Ann, Robert, father Henry, Mary, and August; (second row) Carl, William, Herman, Francis, Emma, Albert, and Gustav. The family's original home still stands today facing north, west of Scott Street.

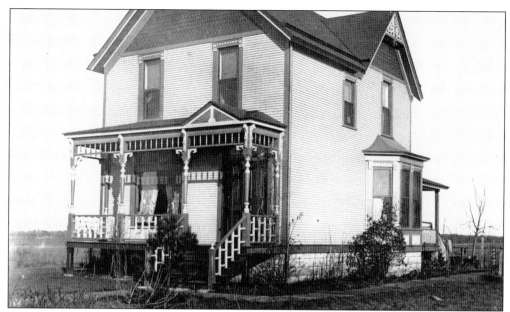

Born on July 19, 1866, Henry George Kirchhoff had entered the wholesale paper business by his 20th birthday. Working for the Thomas brothers of 96 West Randolph Street in Chicago, he began his career as a truck driver but advanced to head of sales within 12 years. On April 9, 1888, he married Grace Katerbau, and he built the home pictured here soon after. It was described at that time as "a home of refinement, suited to the tastes and pursuits of a Christian gentleman," and as "one of the finest in the handsome suburb of Franklin Park."

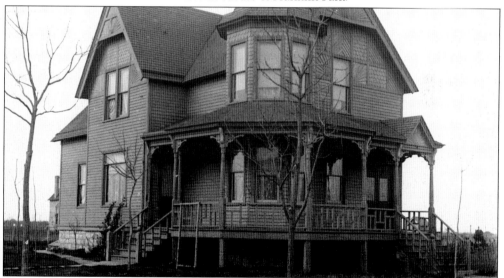

August Bernhard, Henry Kirchhoff Jr.'s second-oldest child, married Elizabeth Ellen Scoffern in 1887. The two met while August was working as an apprentice telegrapher at the Mannheim Railroad Station. The couple built this house at Calwagner and Gage Streets in 1892. The Methodist church was established at a meeting in the parlor of the then-new home on April 25 of that same year. The wooden sidewalks visible in the photograph connected this home to those of August's brothers William and Albert. All three of the brothers built on the 3300 block of Calwagner Street.

William H. Kirchhoff was born the fifth child of Henry Kirchhoff and Mary Ann Kirchhoff (née Franzen) on January 24, 1868. Throughout his adult life, William held administrative positions with several companies including the Davis Sewing Machine Company, the Crane Company, the State Bank of Franklin Park, and Franklin Park Lumber. He was a school board member for 14 years and served as village president from 1915 to 1923. He built this beautiful home at 3316 Calwagner Street for his wife, Alice Kirchhoff (née Martens), in 1893, the same year the couple married.

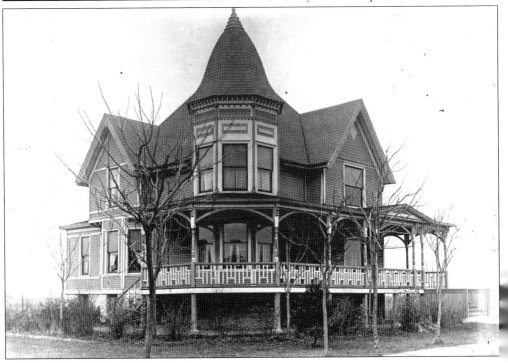

This foursquare, prairie-style home was built in 1925 for Albert and Alma Kirchhoff. It still stands today at 3336 Calwagner Street. Albert was bookkeeper for the numerous Kirchhoff family businesses. The other two Kirchhoff houses on the same block are about 30 years older than this one, due to the fact that Albert was a confirmed bachelor until he was into his 40s. Built after Albert finally married, this house reflects a more modern style of architecture than the homes of his brothers.

The First Ladies Aid Society of the Franklin Park Methodist Church is pictured here in 1892, the same year that the church and the village were formed. Many prominent and long-residing names are represented in this photograph, including Kirchhoff, Martens, Schierhorn, Robinson, Grubbs, Woodruff, and Dodge.

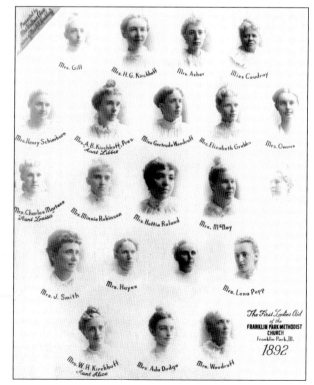

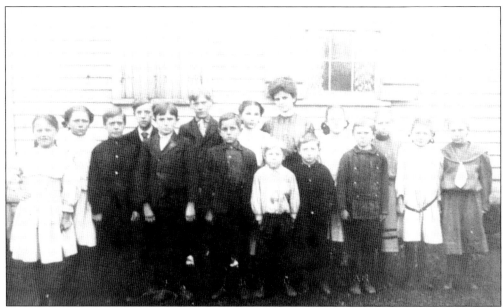

Mannheim School District 83 began in 1869 as a one-room wooden building at the corner of Grand Avenue and Mannheim Road. The teacher shown here (back center) was responsible for cleaning, keeping the potbellied stove going, and teaching students in the first to eighth grades. The school year began in November and ended in March. This enabled children to help with planting and harvesting. In 1936, the Works Progress Administration removed the wooden school and replaced it with a redbrick building, portions of which remain standing today.

By 1855, 2,933 miles of railroad track ended at Chicago's corporate limits. The Chicago and Northwestern, Chicago Rock Island and Pacific, Chicago Burlington and Quincy, and Atlantic and Pacific Railroads were known as the Granger railways, as they served the grain-growing states. In 1865, the Atlantic and Pacific Railroad began laying rail west from Chicago. By the time the rail shown here was being installed in Franklin Park in 1873, the company had changed its name to the Chicago and Pacific Railroad. In 1880, the Chicago, Milwaukee, and St. Paul Railroad purchased the line.

Two

RAILROADS AND THE MANNHEIM COMMUNITY

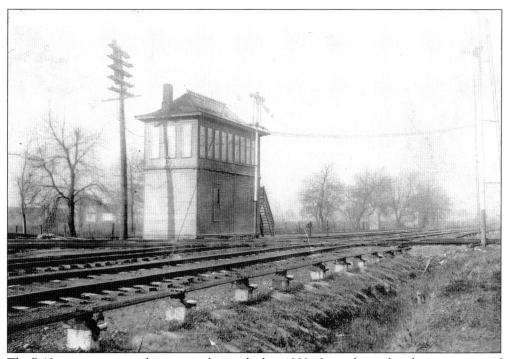

The B-12 tower was erected sometime during the late 1880s. It was located at the intersection of the Atlantic and Pacific and Soo Line Railroads. Tower operators manually opened and closed switches on the tracks to prevent train collisions. The tower was moved to the downtown area of Franklin Park and converted into a museum in 1996.

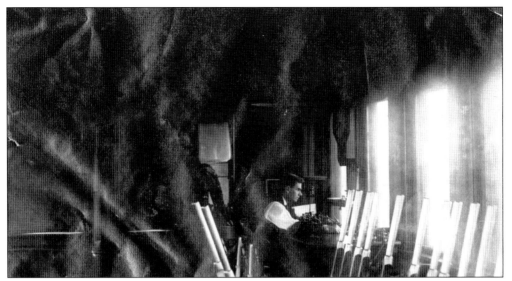

Vernon Reed is shown here sitting at a window in the upper floor of the B-12 tower. The series of levers beside him were connected to mechanical arms that extended down through the building, out through the north wall, and alongside the railroad tracks, terminating at switches. The construction and operation of these switches predated electricity (notice the kerosene lamps overhead). Constant lubrication and arm muscle enabled the actuating of switches up to several hundred feet from the tower.

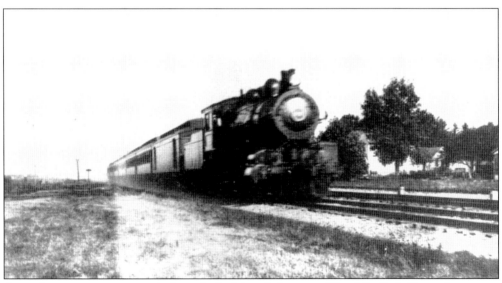

An early passenger train travels through the Mannheim area of Franklin Park. Several more sets of tracks would later be added to the two shown in this photograph of the westbound train.

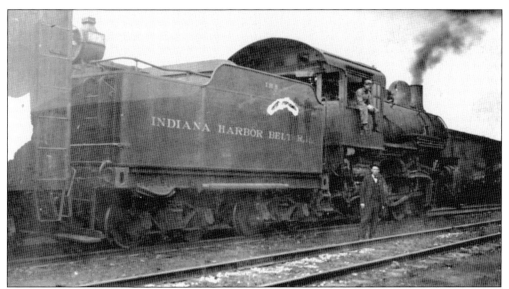

The Chicago Junction Railroad Company built the Indiana Harbor Belt Railroad through Franklin Park in 1896. The Indiana Harbor Belt Company acquired the line in 1907. By 1937, three different railroads shared ownership of the line: the New York Central (60 percent), the Chicago and Northwestern (20 percent), and the Chicago, Milwaukee, St. Paul, and Pacific (20 percent). In this photograph, John S. McNett, a village trustee from 1915 to 1921, is standing beside one of the Indiana Harbor Belt Railroad's engines.

In 1886, land was purchased from local property owners (primarily from the Schierhorn family) for the construction of a railroad. The railroad ran north and south through Franklin Park. The company that owned the line was originally called the Minneapolis, St. Paul, and Saulte St. Marie Railroad, but it was best known as the Soo Line Railroad. The line was subsequently owned by the Chicago and Wisconsin Railroad, the Wisconsin Railroad, and was finally purchased by the Wisconsin Central Railroad in 1907.

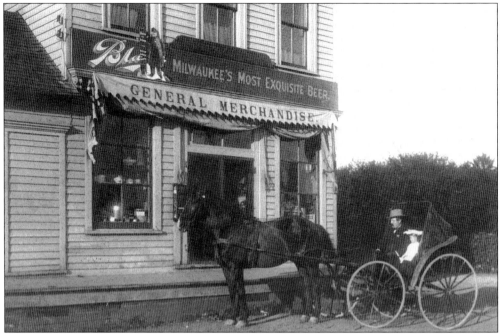

One of the first commercial buildings erected on Mannheim Road was Fred "Fritz" Pfundt's general store. Pfundt, seen here seated in his buggy, was also police chief. His badge is visible on his coat. Assorted housewares can be seen through the windows on the first floor.

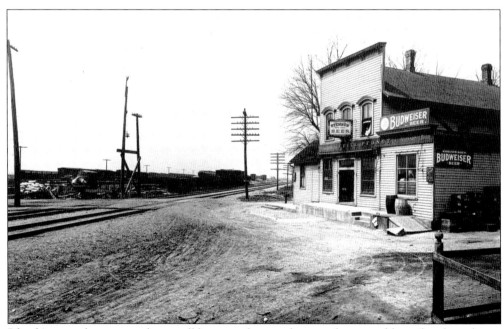

Pfundt's general store was also a well-known saloon and eatery, frequented by railroad employees and early motorists. Located on very rural Mannheim Road, Pfundt's business offered imported and domestic wines, liquors, and cigars. Budweiser and Stenson Beer were available on draught. The large freight scale in front of the building was used for cargo arriving to this busy railroad area.

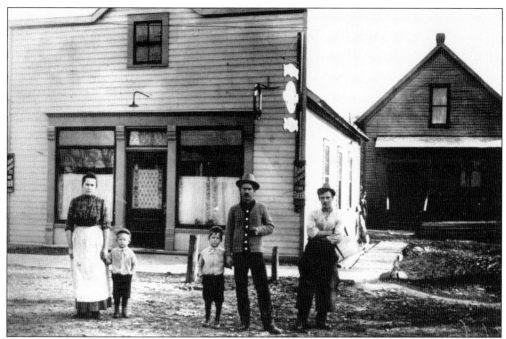

Carl A. Zunker opened one of the first blacksmith shops in the Franklin Park area. It was located on Front Street near Mannheim Road. Prior to when automobiles became the predominant mode of transportation, Zunker's services included horseshoing, carriage and wagon repairs, and a variety of general blacksmithing. His shop, pictured below, was typical of the many buildings clustered at Mannheim Road and the railroad tracks. These buildings are gone today, due in large part to the several phases of the bridge that is located at that spot. After the use of horse-drawn carriages and farming equipment diminished drastically, Zunker converted his shop into a residence. He is shown above (center) with his wife, Sophie, and their sons, Albert, Emil, and William.

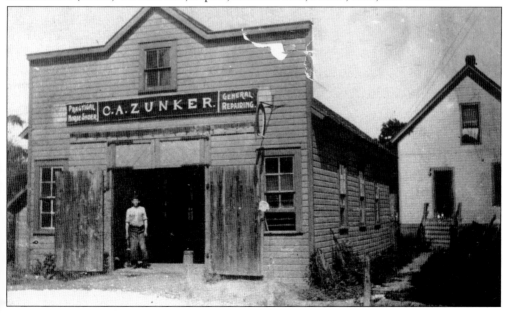

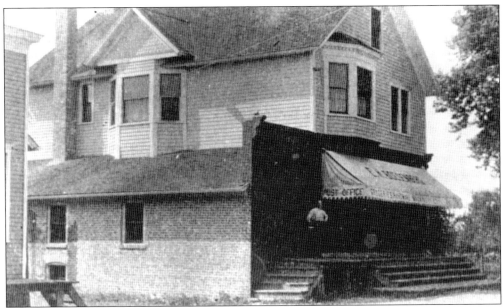

Henry F. Bosenberg and Katherine Marie Heimsoth both emigrated from Hanover, Germany. The two were married on March 23, 1843, in Chicago. Together they purchased several tracts of land totaling 320 acres. Their land was located north of Belmont Avenue and west of Mannheim Road. Bosenberg was elected to numerous Leyden Township offices and became a village trustee in Franklin Park's first election in 1892. Charles Bosenberg, one of his parents' eight children, owned a store on Mannheim Road where he sold general merchandise, coal, and farm machinery.

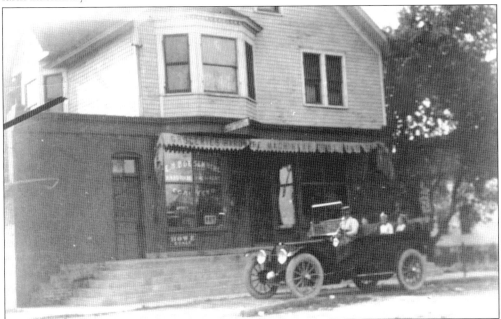

Edgar Bosenberg is visible in the driver's seat of his Mitchell touring car, parked here in front of his family's store on Mannheim Road. This photograph was taken prior to construction of the first Mannheim Bridge in 1914.

34

This photograph was taken prior to the reconstruction and widening of Mannheim Bridge. The Stillman house is pictured adjacent to St. Paul's Church and parsonage. A store was added to the front of the house at 3337 Mannheim Road. The Trentino-Alpine Grove served food and drinks, and there was also a Texaco gasoline at the curb alongside the increasingly busy roadway. By 1939, A. Lorenzini, the proprietor of the building, had renamed it the Alpine Ballroom and Picnic Grove. St. Paul's Church and the Alpine Ballroom were later relocated from south of the bridge.

Pictured here in 1938, the original two-lane bridge on Mannheim Road was completed in 1916. It included a pedestrian walkway on its west side. The bridge provided recreational amusement for local children. Kids were often seen sliding down the sides of the abutment, on sleds in the wintertime or on cardboard over the tall grass during the summer months. Those with the best aim would throw cabbages from the bridge down to the stacks of the steam engines to see them shoot up in the air.

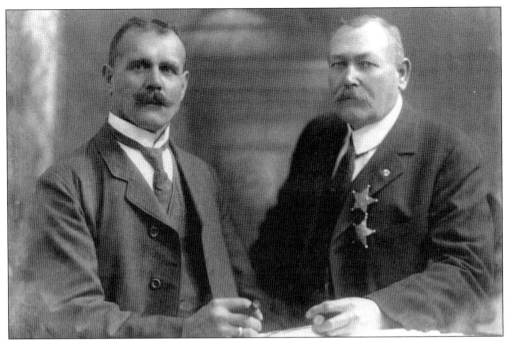

Fred "Fritz" Pfundt (right) was one of the Mannheim area's earliest residents. In addition to operating his general store and saloon, he served as chief of police for Franklin Park. The reason for two badges being present on his lapel while he holds a cigar in this photograph remains unclear. It is possible that he held an additional village or county-appointed position.

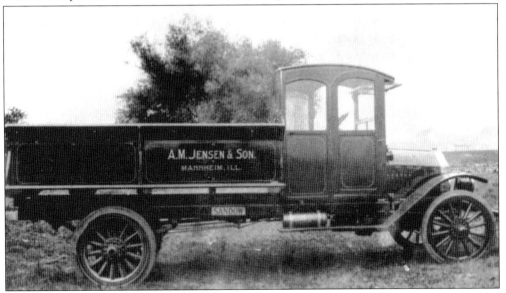

After purchasing their first farm from the Kleinschmidt family at Franklin Avenue and Wolf Road in 1907, Christian and Andrea Jensen farmed several areas around Mannheim Road. Their family of seven children operated farms at Belmont Avenue and Mannheim Road, Fullerton Avenue and Mannheim Road, and along Grand Avenue on portions of the Blume farm. Christian Jensen's son Glen was active in Franklin Park politics, holding the positions of trustee, village treasurer, and fire chief.

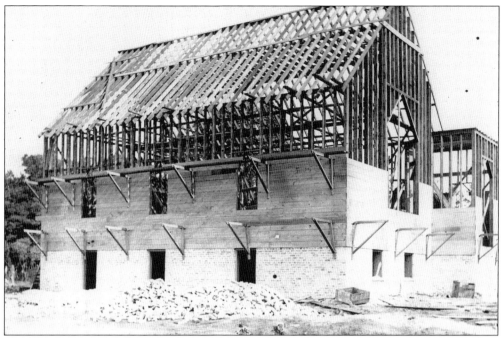

In February 1903, on land donated by Henry Kirchhoff Jr., local farmers formed Deutche Evangelische St. Paul's Kirche von Mannheim. The church was located on the east side of Cleveland Avenue (later changed to Mannheim Road), between Belmont and Franklin Avenues. This early construction photograph shows a brick foundation supporting a frame structure. A three-story steeple was later added above the front entrance.

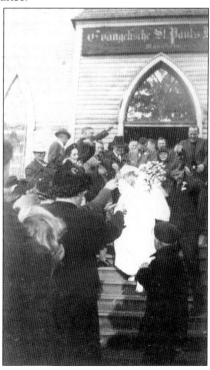

On October 4, 1903, 19 primarily German-speaking farmers dedicated their new church. The sanctuary was completed at a cost of $2,425. Sunday services were given in German during the many years that the congregation met here. Notice the sign positioned above the door as this wedding party exits the church. In 1939, plans for expanding Mannheim Bridge over the railroad called for the condemnation of a portion of the church property. On April 27, 1940, a fire caused considerable damage to the frame building. It was relocated to the other side of town soon after that.

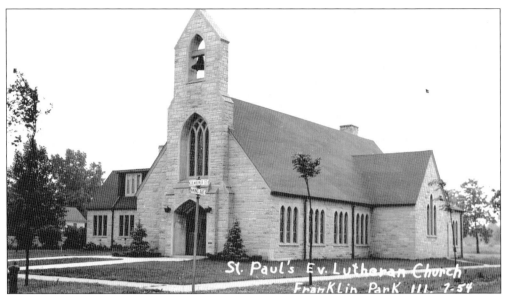

Members of St. Paul's Evangelical Lutheran Church used the band room at Leyden High School as a meeting place until their new building was completed at Calwagner and King Streets. The sanctuary's dedication took place on May 25, 1941. The church bell situated above the front entryway was salvaged from the original building on Mannheim Road. In 1949, the Evangelical and Reformed churches merged with the Congregationalists, and St. Paul's Evangelical Lutheran Church became St. Paul's United Church of Christ.

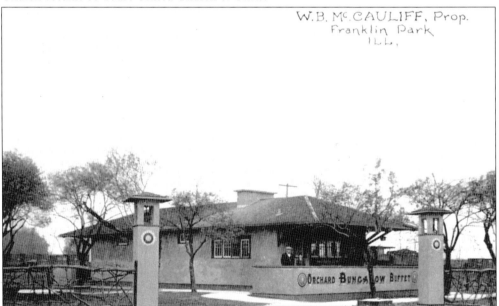

In this rare postcard, the long-popular Orchard Bungalow is shown alongside the railroad (notice the railroad cars in the background). W. B. McCauliff was village president from 1905 to 1915. He began his original restaurant business in the Franklin Hotel. The business soon grew substantially, enabling McCauliff to build his roadhouse in a beautiful orchard on the outskirts of Franklin Park. Today a cement plant occupies this site. The Orchard Bungalow was eventually relocated across Franklin Avenue to Ernst Street.

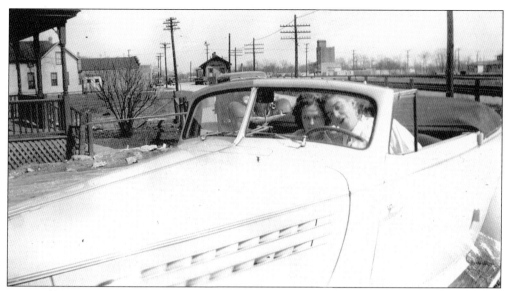

Pictured here are Lincoln Pfundt and his girlfriend, Edith Fox, out for a ride on Front Street. The original Mannheim Railroad Depot and the Illinois Brick Company can be seen in the background.

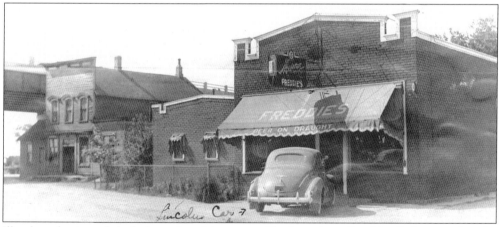

Illegal production of alcohol continued in many stills throughout Franklin Park even after the repeal of the Volstead Act in 1933. Two local moonshiners bought Fred Pfundt's original grocery store and saloon. Pfundt built a new establishment immediately east of his family's first building. Shown in this pre–World War II photograph, Freddie's was a grocery store and saloon that also housed the Mannheim Post Office in an adjacent building. A postmistress was jailed for forging money orders in the late 1930s, resulting in the permanent closing of the Mannheim Post Office.

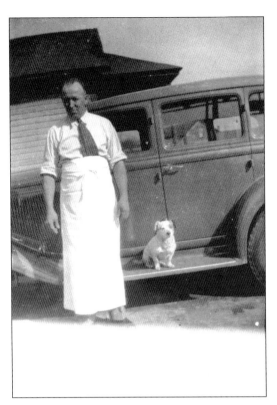

Fred Pfundt Jr., saloon keeper at Freddie's on Front Street, stands alongside his Model-A Ford, while his dog sits on the running board. Pfundt's better-known pet, however, was the monkey shown checking the thermometer in the photograph below. During business hours, the monkey was generally kept loose in the saloon. It had an aggressive personality, so if a patron ever reached behind the counter the monkey would screech and howl, alerting the barkeeper to the problem.

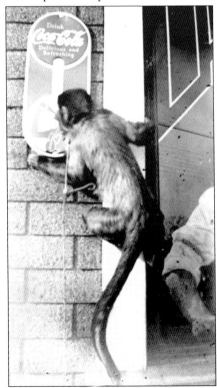

One

LESSER FRANKLIN AND EARLY TOWN IMPROVEMENTS

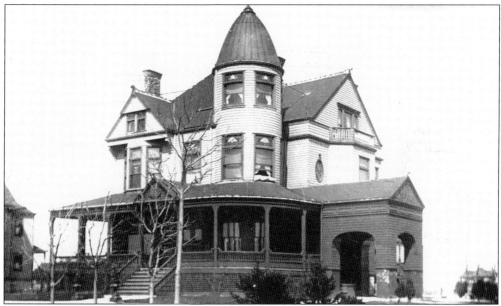

Lesser Franklin's personal residence was the finest home west of Chicago. Located at Schiller Boulevard and Atlantic Street, the east side of the house had a porte cochere where buggies and carriages would bring guests arriving for tours. Upon entering the house, these guests would view hand-painted walls and ceilings with cupids, wreaths, garlands, and floral fantasies. Hand-rubbed wood paneling with family portraits, polished wood floors beneath oriental carpets, and crystal chandeliers gave the first floor a very regal appearance. Lesser and Sarah Franklin's home also boasted a conservatory for flowers, complete with a center fountain containing a statue and a goldfish pond. The library had walls filled with books, paintings, and statuary. Six bedrooms and a modern bathroom composed the second floor. The third floor was intended for entertaining; it included a dance floor, a pool table, and an organ. Prospective buyers were shown a view from the corner windows of the third floor.

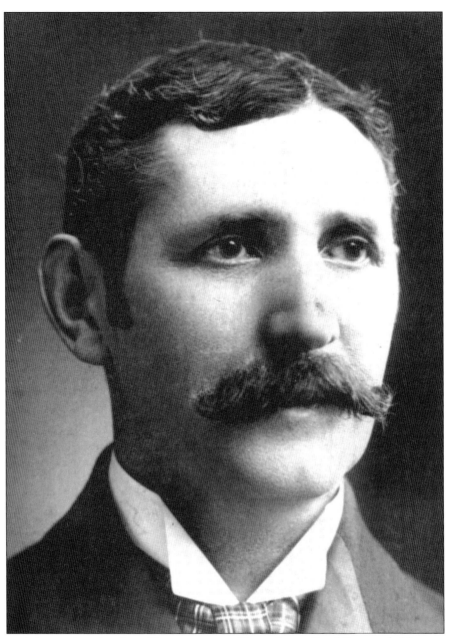

After arriving to America from Germany on a sailboat, Lesser Franklin traveled by wagon to Bedford, Iowa, where he met and married Sarah King. He used his salesmanship skills to sell hardware, and then real estate, first to Minneapolis and then to Chicago. He purchased four farms and subdivided them into the earliest sections of what would become Franklin Park. Improvements to the area including streets, trees, two railroad stations, stores, a hotel, and a palatial home encouraged investors to buy and build in the early 1890s. Unique acts of bartering, including trading lots for a drugstore in South Bend, a stable in Missouri, a men's store in Wisconsin, and a sawmill in Mississippi, preserved Franklin's solvency during the recession that followed the Spanish-American War. Sarah Franklin passed away on May 19, 1908. Her husband's death followed exactly two years later. The couple rests at their family plot in Elmwood Cemetery.

The five children in this photograph are the sons and daughters of Lesser and Sarah Franklin. They are, from left to right, (first row) Rose and Gustav; (second row) Edgington and Pearl; (third row) Dora. During the 1890s, Franklin named some of the town's new streets in his children's honor. He named other streets to honor friends, acquaintances, and employees. Calwagner was Franklin's top salesman, Ruby was his bookkeeper, and King was his wife's maiden name. He named streets for the men he had purchased farms from, Martens and Ernst (Pflug), and Atlantic Street was named for the first barrier that Franklin had overcome during his immigration to America.

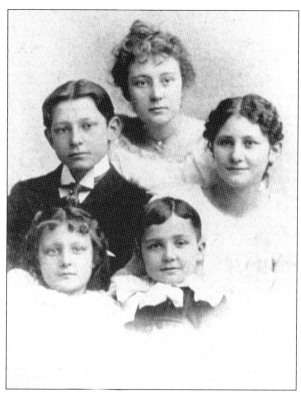

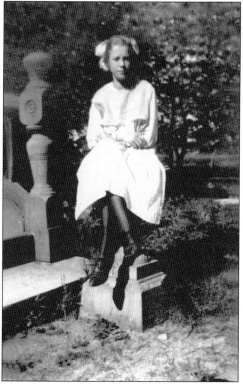

Sitting here at the entrance to Lesser Franklin's home is Elsie Fox, around 1915. The elaborate grounds behind her include vegetable and flower gardens that featured "pink seven sisters," roses transplanted from the Columbian Exposition World's Fair. Also surrounding the house were a barn, windmill, gymnasium, summerhouse, children's playhouse, and grape arbors covered with Delaware and Concord grapevines. Fox, a lifelong Franklin Park resident, would ironically later build a home with her husband, Nick, just 200 feet west of where this picture was taken.

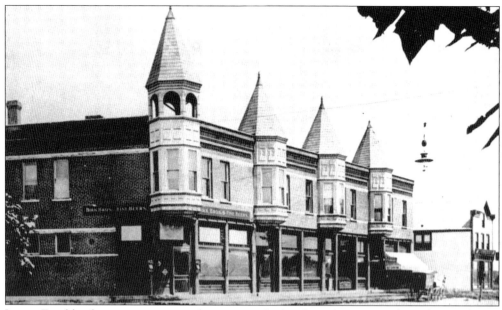

Lesser Franklin began constructing his vision of a bustling downtown along the south side of the railroad tracks. He built this large brick commercial building at the corner of Franklin Avenue and Calwagner Street. The building housed numerous businesses and provided upstairs meeting rooms for many newly forming organizations, including the Methodist and the Catholic churches, a Masonic lodge, and the area's first school classes.

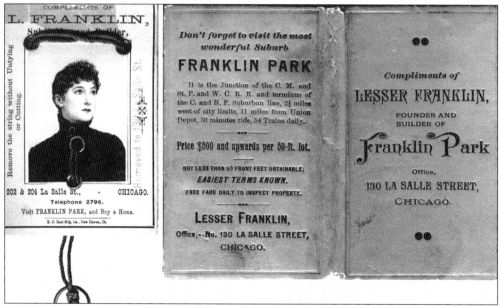

In 1893, excursionists traveling by train from Chicago's Colombian Exposition arrived to Franklin Park's new railroad station. Here they were greeted by Franklin, the man behind the construction of the new station, and by his salesman. After being escorted down Franklin Avenue to the pavilion at Rose Street, the guests were welcomed with a party. A band played for the best waltz dancers, and prettiest baby contests were held. Children's games would ensue, and souvenirs, like the ones shown here, were given to all who attended.

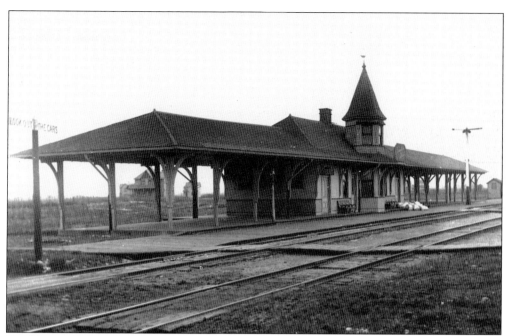

Franklin used different methods to entice potential buyers for his developing community. He would stage parades on LaSalle Street and host parties for travelers attending the Colombian Exposition. Franklin built these two train stations, their purposes being to greet guests arriving to town. The open-ended station with the turret in the center was originally located west of Calwagner Street where the Franklin Park Pool stands today but was moved one block east some time later. The other station with the men in derbies, standing on the platform in front, was built along the Wisconsin Central (Soo Line) Railroad at Commerce and Chestnut Streets. The Franklin Park sign from this station hangs in the second floor of the B-12 tower today.

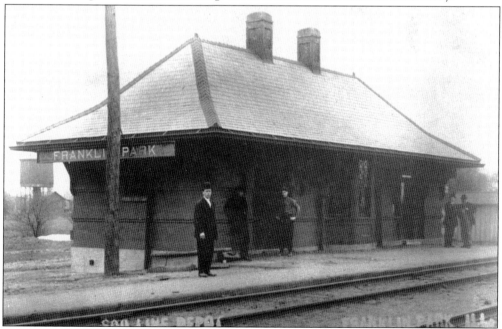

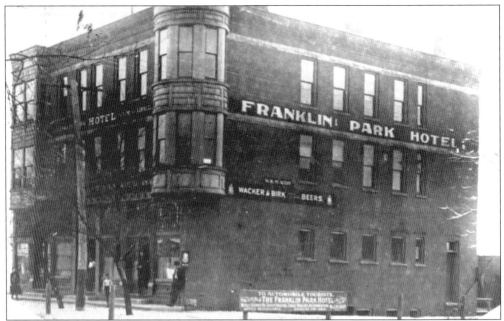

In a letter written in 1942, Pearl Franklin Clark fondly recalls living in her father's new hotel for a few weeks, while the family's house was being built during 1890: "I used to help Kate, who was my age, in her duties of setting the long tables and of polishing the tumblers which were carefully turned down at each place." Stores located on the first floor of the hotel included a butcher shop and a restaurant and bar operated by policeman and future village president William McAuliff. Court was convened at the rear of the tavern. It was the largest hotel west of the city's limits in northwest Chicagoland.

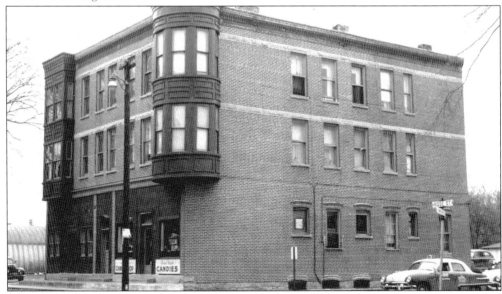

The Franklin Park Hotel changed little over the next 60 years. In this photograph, fewer stores appear, and the pointed roof turret has been removed. The redbrick and limestone construction matched that of the large commercial building at Franklin Avenue and Calwagner Street. Both structures were built by Lesser Franklin's instruction. The hotel was razed in 1956.

James O'Malley opened Franklin Park's first grocery store in 1898. It was located inside Franklin's redbrick building at the northeast corner of Franklin Avenue and Calwagner Street. In 1906, the business moved across the street. Peter Mulroy then joined the firm along with O'Malley's nephew. This receipt, dated April 25, 1918, shows a typical outstanding balance with new purchases totaling 43¢.

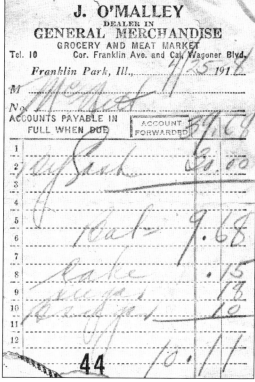

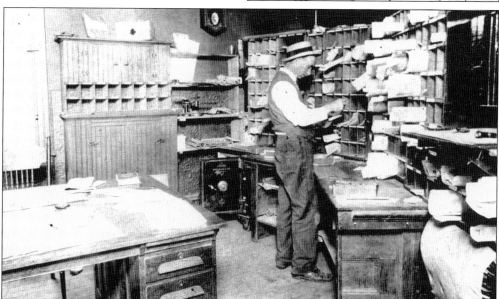

Arthur E. Wasson sorts mail in the corner of a room at Rose Street and Franklin Avenue, in the earliest photograph of the Franklin Park Post Office. Wasson came to Franklin Park from Greenfield, Iowa, in 1897. He was a postmaster for 25 years and was also employed by the Chicago, Milwaukee, and St. Paul Railroad for 53 years. Wasson served on the board of education for 20 years, while he and his wife, Fannie Louise, had four children of their own: Helen, Ruth, Wilbur, and Harold.

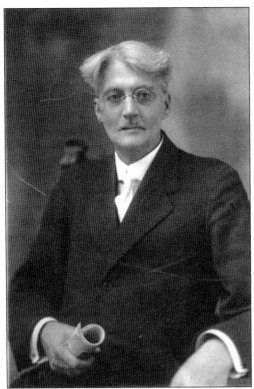

Prior to 1893, Dr. Tope of Oak Park was the physician closest to Franklin Park. Harold E. Dodge graduated from Rush Medical College in 1890. Dr. Dodge and his wife, Ada, purchased the redbrick house on Rose Street north of Belmont Avenue and opened a small office alongside their home. Dodge and his wife were involved in the formulation of Leyden High School, the Red Cross, and the Leyden Masonic Lodge. After Dodge passed away in July 1936, the entire Leyden High School band escorted the funeral procession to his final resting place at Edens Cemetery in Schiller Park.

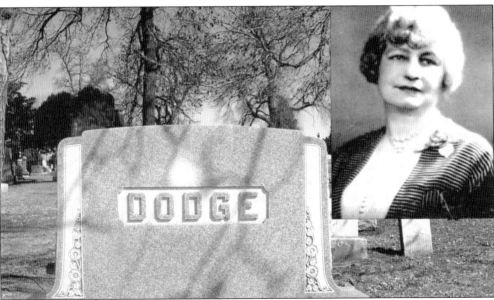

Harold and his wife, Ada, came to Franklin Park in 1893. The couple resided at 3234 Rose Street. Ada often accompanied Harold, Franklin Park's first doctor, on horseback during house calls. The Dodges had no kids of their own but were keenly interested in the children of the community. Ada was a member of Leyden High School's first board of education and served as president of this group for many years. Dodge Lane and Dodge Field behind East Leyden High School were both named in the couple's honor.

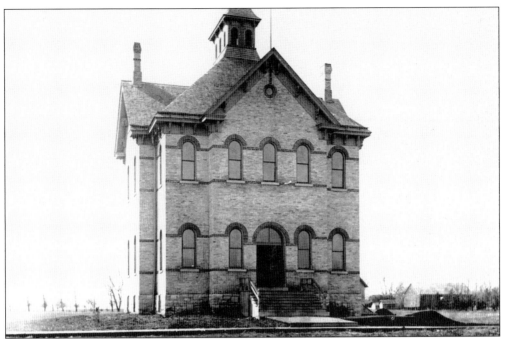

Some of the first elementary school classes in Franklin Park were taught in rooms above stores in Lesser Franklin's redbrick building at Calwagner Street and Franklin Avenue. Franklin donated desks and other furniture to the classrooms until this four-room schoolhouse was completed at Gustav and Chestnut Streets in 1895. Mary M. Lalor was the school's first teacher and principal. A two-room portable building was added in 1913, which offered two years of high school education to students. If they wished to graduate, the students would then have to attend Proviso High School in Maywood.

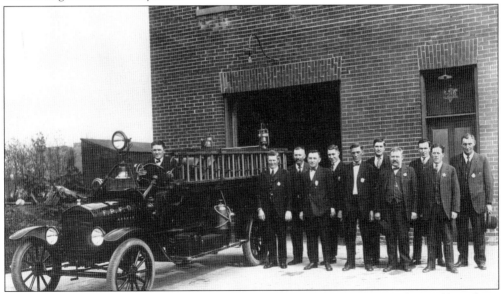

Franklin Park's first motorized fire truck was this 1914 Model T. Notice the police emblem above the door on the building in the background. This public facility on Atlantic Street served as home to the police and fire departments, as well as the village administration.

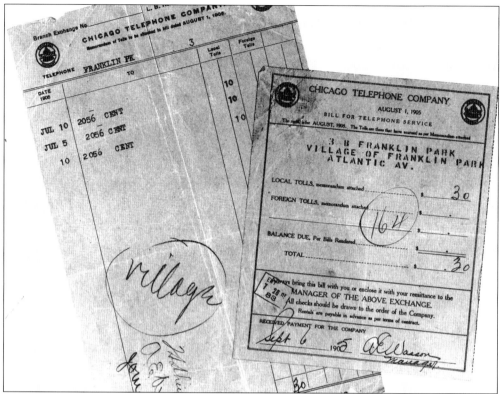

In 1905, 13-year-old Franklin Park had only 46 telephone lines. The village offices on Atlantic Street just south of Franklin Avenue were positioned above the police and fire department. This photograph shows that just one telephone serviced the municipal building, with charges for the month of July totaling 30¢ for three local calls. The bill was approved by Mayor William McAuliff and trustees Wasson and O'Malley.

This photograph, dated January 22, 1908, shows Franklin Park's first successfully drilled artesian well. The well was 1,406 feet deep. Two additional wells were added at this location, their purposes being to supply water to the village. Water was then stored in a ground-level reservoir and in the water tower. The Franklin Park Community Center stands at this location today.

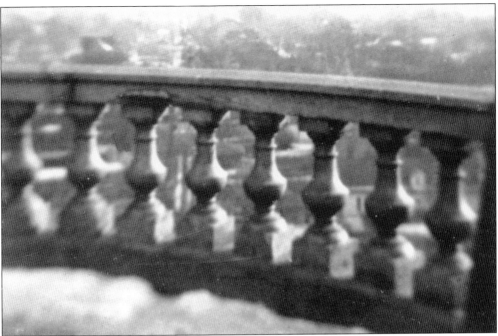

Standing here on six legs is Franklin Park's first elevated water tank. Designed and built by H. L. Emerson in 1908, the large structure was located near the corner of Franklin Avenue and Rose Street. The 55,000-gallon tank was constructed of reinforced concrete. It stood 100 feet tall and included a central enclosed staircase that passed through the tank and exited out onto an observation deck. The beautiful balustrade railing surrounding the deck allowed residents to safely ascend and view the growing community. Many photographs of Franklin Park taken from an elevated position exist today because of the popularity of this tank's unique feature.

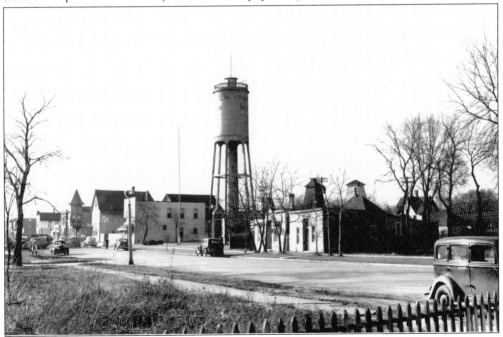

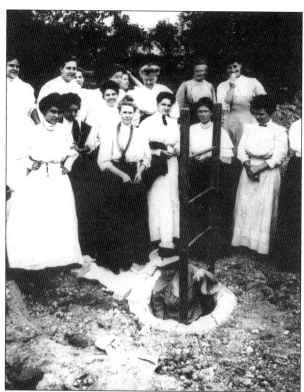

Upon completion of Franklin Park's first sewer, a party was held in its location on Schiller Boulevard. Here Lesser Franklin's daughter Dora leads a group of the town's ladies down into a most unusual dedication banquet.

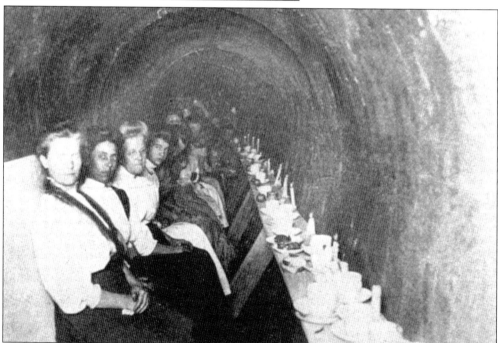

Long benches were set up along each side of the oval-shaped sewer in preparation for the buffet dinner served on September 23, 1908. Notice the complete china set and candles along the wall. This event predated electrical illumination in Franklin Park.

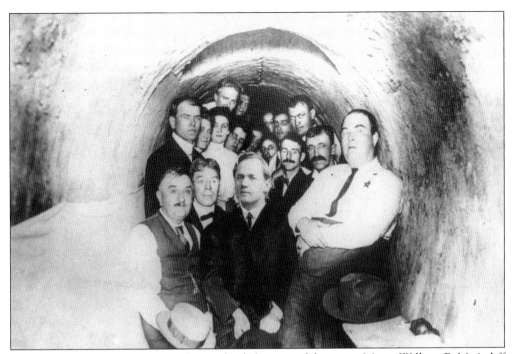

Village officials are shown posing during the dedication of the sewer. Mayor William B. McAuliff (front right) gave a dedication speech, as did village engineer H. L. Emerson. The man in the front and center of the group seems to have been superimposed into the photograph.

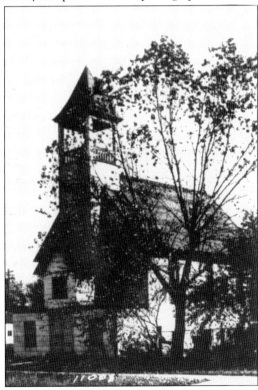

On April 3, 1892, residents of the area met at Franklin's pavilion at the northeast corner of Franklin Avenue and Rose Street and decided to form the First United Methodist Church of Franklin Park. Worship services were held at the pavilion, above John Martens's store (until a disastrous fire in May 1895), and above the stores in Lesser Franklin's redbrick building at Franklin Avenue and Calwagner Street. In August 1897, this 24-foot-by-36-foot structure was completed at Franklin Avenue and Gage Street for $1,200. It was eventually moved to Schiller Park.

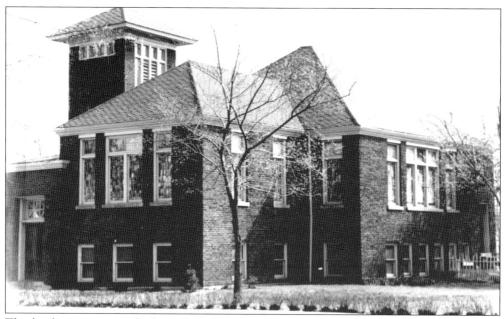

This brick sanctuary was built in 1911 to accommodate the growing Methodist congregation. It was built adjacent to their first building that had been erected 14 years earlier. The $8,800 cost was raised quickly, and volunteer labor completed the sanctuary's construction with ease. After the older structure was moved to Schiller Park, a parsonage was added to the property, originally donated by Arthur E. and Fannie Louise Wasson. The brick sanctuary housed the Methodist population for 45 years. In 1956, it was sold to the Episcopal diocese for $28,500. The building was razed in 2005.

The Leyden Masonic Lodge, decorated here for Franklin Park's 50th anniversary in July 1942, was actually the first site of St. Gertrude's Catholic Church. Father M. B. Krug headed construction of the church and rectory at the corner of Franklin Avenue and Ruby Street in 1901. The building was vacated 14 years later, eventually being utilized as a machine shop during World War I. Local physician Dr. Henry Dodge organized the Leyden Lodge No. 993 A. F. and A. M. at the "White House" in Schiller Park during September 1914. In 1920, the lodge purchased this building and then occupied it for the following 46 years.

Four

THE EARLY 20TH CENTURY, WORLD WAR I, AND THE DEPRESSION

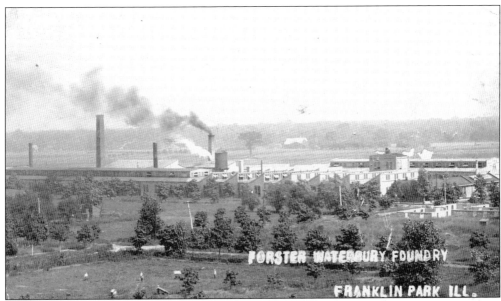

In 1894, two years after the incorporation of Franklin Park, the United States experienced a financial crash. Previously brisk sales of building lots slowed considerably. In 1898, the nation became involved in the Spanish-American War. In an effort to rouse property sales, Lesser Franklin donated a tract of land for the building of a foundry in 1900. The land was located north of Belmont Avenue alongside the Wisconsin Central Railroad. Once built, the industry created jobs for Franklin Park residents and stimulated sagging real estate sales by bringing new inhabitants to town.

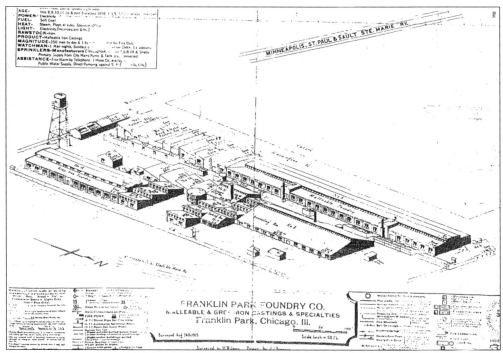

The Foster Waterbury Foundry Company built this sprawling complex in 1900. The company produced malleable and grey iron castings. It became the Franklin Park Foundry in 1912 and then a short time later, became Central Malleable Castings. In 1929, Howard Foundries purchased the property, but the Great Depression forced this company to close the facility, leaving the complex abandoned.

Mailed in November 1914, this postcard featured the many improvements and attractive amenities in Franklin Park. These included a river setting, churches, a new school, industry, and a growing downtown.

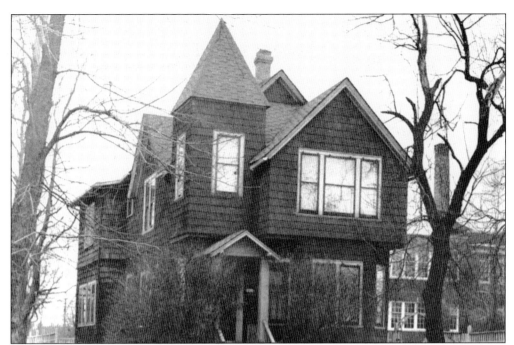

William B. McAuliff came to Franklin Park in 1891. He began his career as a policeman, soon becoming chief of the early department. He became a village trustee in 1901, serving in that capacity until 1905, at which time he was elected to the position of village president. During his ten-year presidential term, McAuliff's efforts to improve Franklin Park included sidewalks, streetlights, a sewer system, and a water system complete with an elevated water tank. He opened a restaurant and saloon inside the Franklin Hotel that became so popular he had to eventually relocate it to another building on Mannheim Road. The above photograph of the original McAuliff house was taken after St. Gertrude's Catholic Church purchased the property and began using the house as a convent. The residence was moved to 2835 Ruby Street in 1957. McAuliff passed away at age 49 on July 26, 1917.

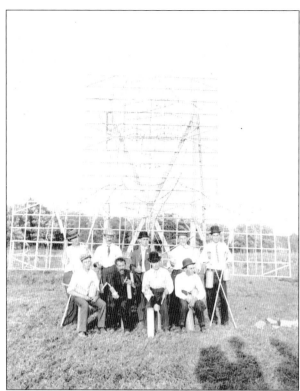

Holding a variety of pyrotechnic items in their hands, these nine men are shown posed in front of a fireworks ground display. The face designed on the display is that of Mayor William McAuliff. The Weigand Fireworks Company at Scott and Pacific Streets specialized in political campaign fireworks. Several more fireworks companies were located in and around Franklin Park, including United Victory Fireworks on Ruby Street, Liberty Fireworks on Rose Street, and Acme Fireworks on Fifth Avenue. During World War I and World War II, some of the companies in this industry were involved in defense work.

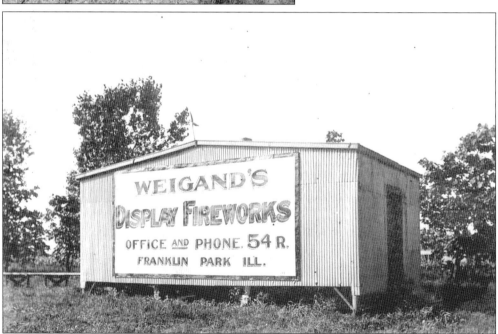

Numerous fireworks facilities were located in Franklin Park after 1900. Some of these included Gregory, Liberty, American, Acme, United Victory, and Weigand Fireworks. The building shown here at Scott and Pacific Streets was eventually converted into a house for Frank and Flava Weigand.

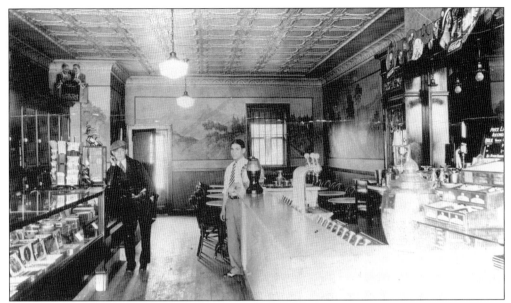

Emigrating from Sicily in 1912, Anton Puglia came to Franklin Park and opened a candy store and ice-cream parlor at the southeast corner of Atlantic Street and Franklin Avenue. Two years later, he and his brother Charles expanded the business, offering fresh produce delivery to local grocery stores. The Puglia brothers relocated their candy store to a large yellow brick building that they constructed at the southeast corner of Rose Street and Franklin Avenue in 1930. The case on the left side of the store contained a large variety of cigars offered for sale.

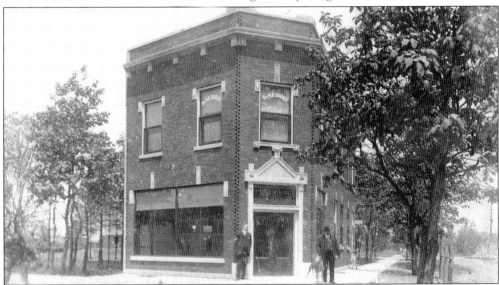

The State Bank of Franklin Park was built at the corner of Calwagner Street and Franklin Avenue in 1910. Officers of the bank included Charles Martens, William and A. B. Kirchhoff, and Dr. Henry Dodge. The trees on the left-hand side of the structure were removed for an addition made by the Farver family, who reopened the building as a Rexall Drugstore during the 1930s. The trees to the right were cut down to create space for parking in the 1950s. Notice the church steeple in the background. This was the first sanctuary built by the Methodist church, erected in 1897.

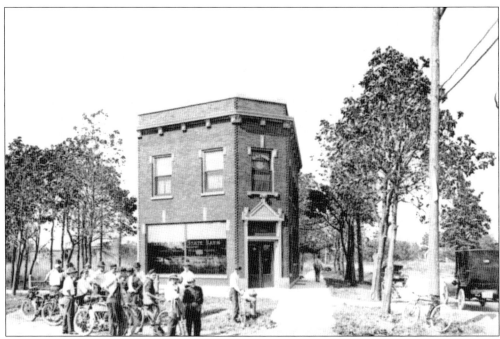

Early motorcyclists congregate in front of the State Bank of Franklin Park at the northwest corner of Franklin Avenue and Calwagner Street. Notice the carbide headlights on these bikes. By 1915, Franklin Park was being selected as a destination spot for weekend automobile and motorcycle excursions out into the countryside. (Courtesy of Chicago Historical Society.)

Brothers Ralph and Robert Larson opened one of the first automobile repair shops in Franklin Park. The building standing in the background of this photograph, taken in 1913, was located at 3116 Rose Street. Notice the early gasoline pump at the curb. Pumps like this predated filling stations in town.

Fred Meyer developed several buildings in Franklin Park over a period of seven years. Some of these buildings included three stores at the northwest corner of Franklin Avenue and Rose Street, J. H. Darts Grocery at Franklin Avenue and Gustav Street, St. Gertrude's Catholic Church at Gustav Street and Schiller Boulevard, and a number of homes and two-flats. Frustrated by the slow growth of the community, Meyer once proclaimed, "Why does Franklin Park remain a little village with its one little main street? Will the building of homes bring the people and the desired spirit of progressiveness to Franklin Park? What about the 1,500 men employed at the C. M. and St. P. railroad yards at Mannheim? Are we to get those people in Franklin Park or are we going to let them go to Bensenville or some other town because we have no homes for them to live in?" He decided to run for village president in 1919, but despite his remarkable campaign literature depicting all of the homes he had built in town, Meyer and the "Citizens Ticket" lost the election.

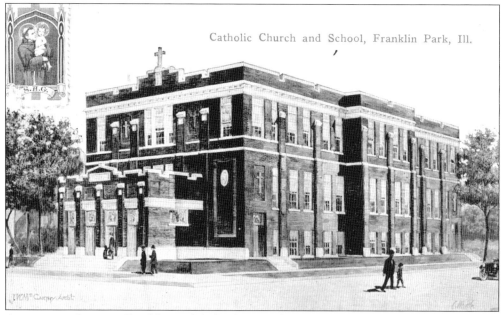

Catholic Church and School, Franklin Park, Ill.

A rising population in Franklin Park helped create the need for a larger building to house the growing congregation of St. Gertrude's Catholic Church. Rev. L. P. Hurkmans arrived in 1912. Construction of the new church building began after property was acquired at Gustav Street and Schiller Boulevard. The building's completion and dedication took place on Palm Sunday, April 5, 1914. This construction of one of the largest structures in Franklin Park to that date was executed by local contractor Fred Meyer.

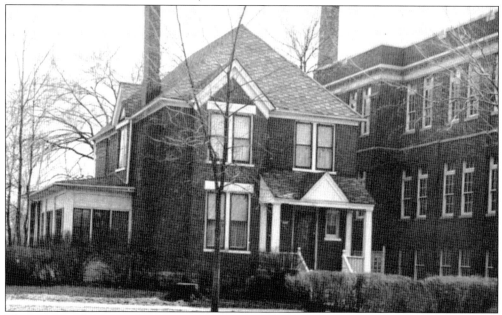

This attractive house was located east of the original St. Gertrude's Church building. The rectory was later expanded when an addition was made to the northeast front corner. The construction of the church's newer sanctuary at Rose Street and Schiller Boulevard, beginning in July 1952, resulted in the razing of this dwelling.

The Garden Deluxe Grove was located at 2900 Commerce Street, adjacent to Andrew Peterson's Saloon (later the Chestnut House), just north of Chestnut Street. Benches surrounded the inside perimeter of this gazebo-like structure. Sand or sawdust was spread across the floor for dancing. Johnny Esposito and the Rhythm Rascals would often provide music for occasions here.

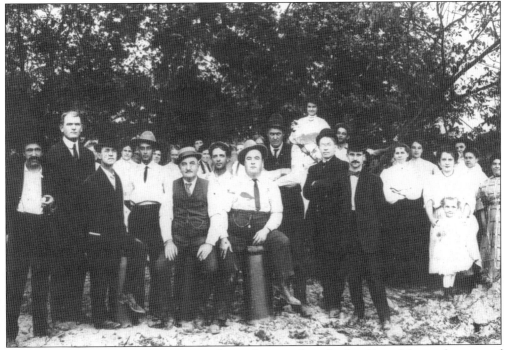

The Garden Deluxe Grove was a popular gathering place for families, clubs, and groups of politicians. Mayor William B. McAuliff (front center) is shown surrounded by many of the same individuals who were present in the photograph of the Schiller Boulevard sewer dedication.

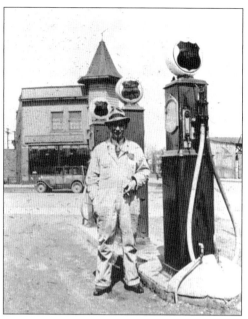

The always-colorful Mayor Barney Reeves stands, with cigarette in hand, beside a few gas pumps on the southwest corner of Rose Street and Franklin Avenue.

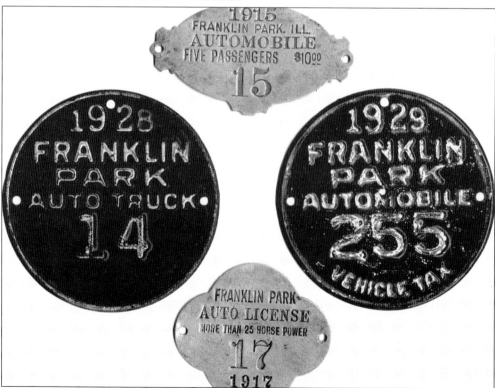

The arrival of cars to Franklin Park is purported to have begun when Dr. Harold Dodge brought his 1908 Mitchell automobile to town. Vehicles began being registered to Franklin Park shortly after 1900. The earliest vehicle tag shown in this photograph is from 1915, and it displays a price of $10. That was a lot of money at the time. On January 24, 1930, during the Great Depression, the price of tags was reduced to $5.

Robert Larson opened a Studebaker and Ford dealership after he relocated the Franklin Park Garage, his original business, to a new building at 3026 Rose Street. During World War II, Larson converted the building into a bowling alley, which was demolished decades later on June 1, 1981. The Larson family lived in the bungalow next door to the building that housed the bowling alley. That residence still stands today.

Popular local businessman Robert Larson's wake took place atop lanes one and two inside his Rose Bowl bowling alley.

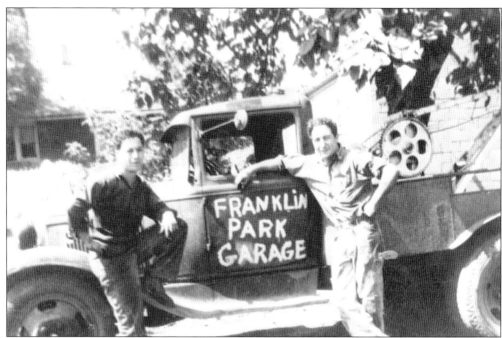

After returning from World War II, naval veteran Sam Asta, shown here resting his arm on the door of his Model A tow truck, joined his brother Joseph in the automobile repair business. The Asta brothers inherited the name of their business, the Franklin Park Garage, from Robert Larson, who originally ran the repair business out of his building on Rose Street prior to the war. Sam Asta later built his own repair shop at 9452 Belmont Avenue and repaired cars there for the following 35 years.

Sam and Joseph Asta, shown here standing in front of their 1929 Model A Sport Coupe, were the sons of two Italian immigrants and longtime Franklin Park residents. The brothers repaired cars and trucks for many years before selling their business in 1980. Joseph passed away on the very day the sale took place. Sam, however, moved to Florida and is still living there today at age 90.

The first grammar school in Franklin Park was the old brick school at Gustav and Chestnut Streets. Mary M. Lalor was the school's first teacher. She taught there for more than 40 years. In 1917, a larger school was built next door to accommodate the growing student population. By 1930, it was called Main School. On November 14, 1971, after numerous modifications, the name was officially changed to Hester Junior High School, in honor of the many years of service that Vance Hester dedicated to District 84.

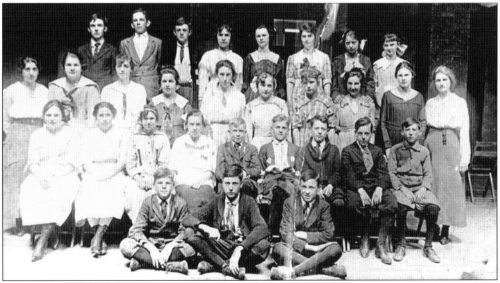

This photograph shows the entire high school class of 1918. From left to right are (first row) Victor Gladish, Eddie Stewart, and Bill Killoran; (second row) Margaret McEvoy, unidentified, Celia Rubino, Lillian Bauer, Tom Kirchhoff, Frank Martens, Emmis Dillon, unidentified, and Earl Happesch; (third row) teacher Albertine Walther, Georgia Shepard, Helen Protz, Lucy Montisano, Rose Tuttle, Sara Anderson, Florence Mack, Marion Peckham, Nevada Voelkel, and teacher Ruth Grimes; (fourth row) Harold Taylor, Bill Mahler, unidentified, Bessie James, Bessie Richardson, Beulah Taylor, Alice Grubbs, and Ruth Wasson.

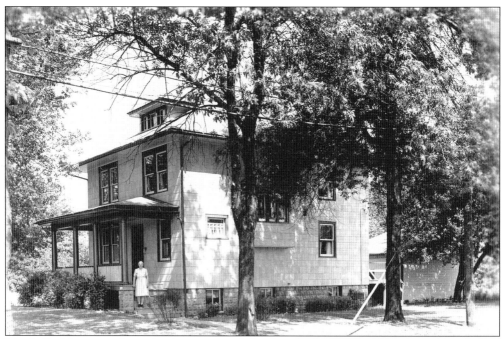

Myrtle Peckham stands on the front stoop of this house at 9502 Grand Avenue. She came to Franklin Park with her husband, Walter, and their three daughters in 1911. Like many others, Walter Peckham worked for the railroad as an operator in the B-12 switch tower. District 84 schools own the old Peckham house today. Walter Peckham served as village clerk from 1914 to 1924 and was involved in the early formulation of Leyden High School. He also served on District 84's school board for 12 years.

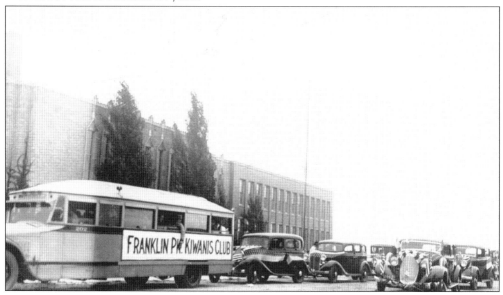

A two-year high school program began at the old brick school in 1913. The program required its participants to attend Proviso High School in Maywood for two additional years in order to graduate. Leyden High School, pictured here, was constructed and dedicated in 1927. The plaque that first marked the school's dedication is still presented in a hallway on its first floor.

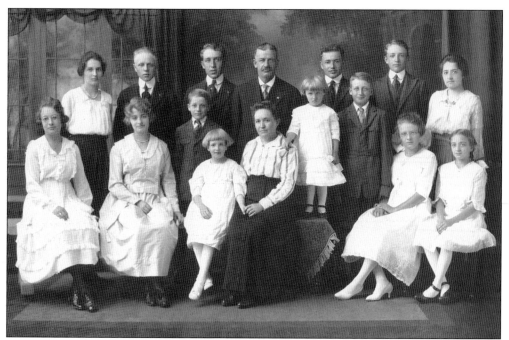

John Didier, born in 1866, began farming south of Grand Avenue in 1917. He and his wife, Catherine, built a new home at 2933 Atlantic Street in 1928 to house their family of 14 children. Didier, who always listed himself as a retired farmer, served as a village trustee until 1949 and then passed away at age 90 on November 27, 1956. Posing in this family photograph are, from left to right, (first row) Geraldine, Agnes, Nicholas, Marie, mother Catherine, Dorothy, Matthew, Katherine, and Francis; (second row) Margaret, George, Joseph, father John, Peter, Jack, and Anne.

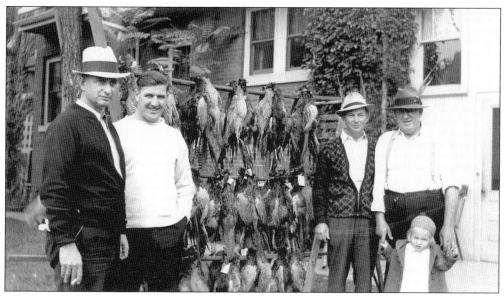

From left to right, Wallace Cundiff, Ray Sapp, Mayor Barney Reeves, and John "Pa" Didier, standing behind an unidentified little girl, display the results of a weekend hunting trip beside the Didier house at 2933 Atlantic Street.

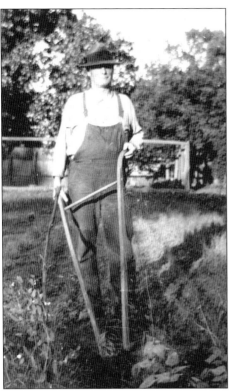

Spanish-American War veteran Charles Fox Sr. came to Franklin Park in 1915. In 1923, he purchased a house at 3225 Louis Street, plus the remaining open property north to Franklin Avenue. He stands here with a plow, planting a garden on that open land. Fox's daughters Laura and Dorothy eventually built homes here.

The Foxes were one of the larger families to live in Franklin Park with 12 children total. Charles worked for the Indiana Harbor Belt Railroad. The majority of his children married into other well-known Franklin Park families, including the Riccis, the Pfundts, the Halversons, the Steins, and the Shannons. Pictured in this 1956 photograph are, from left to right, (first row) Katherine, Raymond, mother Anna, William, and Dorothy; (second row) Richard, Florence, Millie, Robert, Elsie, Chuck, Edith, and Laura.

Michael Latoria left Carbonara, Italy, at age 14, arriving to Ellis Island in 1885. Latoria soon moved to Chicago where he met a young woman named Rose, whom he married in 1907. The couple moved to Franklin Park with their family in 1918. They had 10 children at that time, and the family grew even larger through the years. The Latorias' first home had a dirt floor and was located at the old Mannheim Golf Course on Addison Street. Michael worked on several railroad construction projects and also farmed, sometimes up to 600 acres at a time.

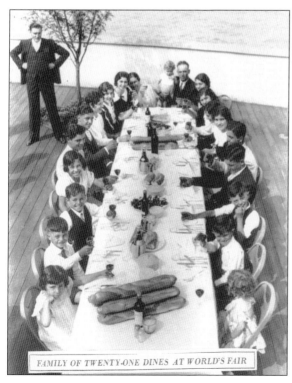

FAMILY OF TWENTY-ONE DINES AT WORLD'S FAIR

By 1934, Michael and Rose Latoria had parented their 20th child. At the Century of Progress World's Fair in Chicago, the Latorias were honored as the largest living Italian family. Ford Motor Company provided 11 new vehicles that transported the entire family to the city, where they were entertained by the Detroit Symphony Orchestra inside the Ford Gardens. Seven of the Latoria sons served in World War II. On Mothers Day 1947, Rose Latoria was named "World Champion Mom." Michael passed away on November 28, 1972, and Rose's death followed on September 25, 1976.

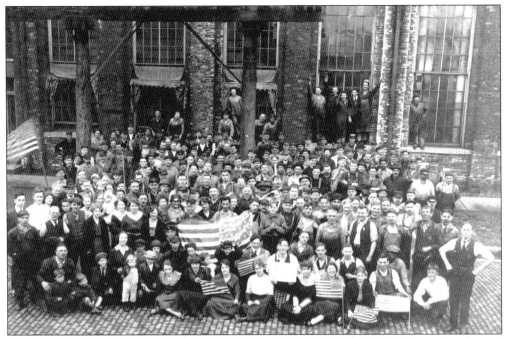

The newspaper being held up in the front row at this employee celebration announces the end of World War I. The Franklin Park Foundry, pictured here, contributed to the Allied victory through its capacity to produce needed war machine materials.

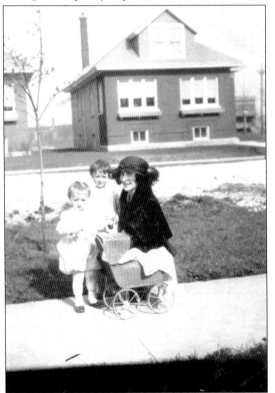

Arvis and Yvonne Emigh are pictured here in 1921, pushing their doll carriage in front of their new house at 3306 Rose Street. Their parents, Mildred and Vernon, moved the family to Franklin Park in 1917. Vernon began his career as a switchman in the Soo Line Railroad yards in Schiller Park. Small trees were planted in the unpaved street's parkway, which eventually grew to maturity and created a canopy on both sides of the roadway. Unfortunately, the parkway was narrowed, and trees were cut down during the 1970s so that the pavement could be widened.

Robert and Wallace Cundiff moved to Franklin Park after World War I in 1919. Like many others who were moving into the community, they worked on the railroad. Both men worked for the Indiana Harbor Belt Railroad, Robert as an engineer and Wallace as a fireman. Pictured here behind the original Puglia building at Atlantic Street and Franklin Avenue are Wallace Cundiff's three children, Jim, Lois, and Lorraine.

MRS. J. W. STACKLAND
GENERAL DRY GOODS

Franklin Park, Ill., _____ 19___

Received of _____

_____ Dollars

Signed _____

In 1912, the same year that the *Titanic* took its fateful voyage, Mr. and Mrs. Jack W. Stackland opened a dry goods store at 9718 Franklin Avenue. The Stacklands remained Franklin Avenue merchants for many years. Their store featured a wide array of products, including graniteware, glassware, boots, shoes, rubber outfits for men, candies, and toys.

Ernest Siebold succeeded William Kirchhoff as village president, after he defeated a young William McNerney by 136 votes in 1923. He led efforts on many village-wide improvements. The most significant of these improvements were $350,000 worth of street paving and $90,000 worth of sidewalk construction. The installation of an additional 100 streetlights, the erecting of street signs on all of the village's streets, and the introduction of a house numbering system all improved the character of Franklin Park's neighborhoods. Siebold was reelected several times, even winning a four-way race in 1929.

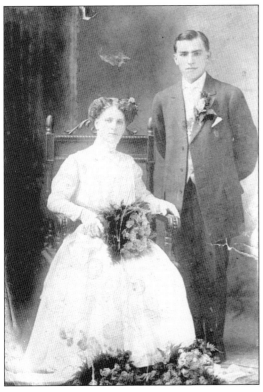

Paul Talaga married Valenia Romanski in June 1912. In 1925, the couple moved to 3446 Ruby Street. The Talagas had five children. Many of their descendants live in the community today.

Theodore Talaga (far left), being assisted by a neighbor and his brother Walter (far right) cuts old railroad ties at 5¢ apiece. A saw made from a Model A Ford chassis sits on the property at Lesser and Ruby Streets. The old Renneggi house at Addison and Ruby Streets is facing north toward Schiller Park in the background of the photograph.

In 1926, Casimir, Theodore, and Walter Talaga, from left to right, celebrated their First Holy Communion. Walter was the oldest of the three brothers. Born in 1913, he attended Leyden High School and then DePaul University, majoring in finance and economics. Walter worked as the Village of Franklin Park's comptroller for 10 years, managing the village's finances with a strong, conservative style. He wrote many articles for local papers over the last 40 years. He passed away in 2006 at the age of 92.

John B. Kroll, owner of the Easson Brush and Broom Company of Chicago for 16 years prior, campaigned for village trustee expounding on his business ability. Elected to village trustee by 96 votes in 1930, Kroll joined 500 other residents in celebrating the completion of Belmont Avenue from River Road to Rose Street on July 31, 1930. He was then elected to village president in 1931, during the height of the Great Depression. Kroll was easily defeated for reelection by Barney Reeves in 1933.

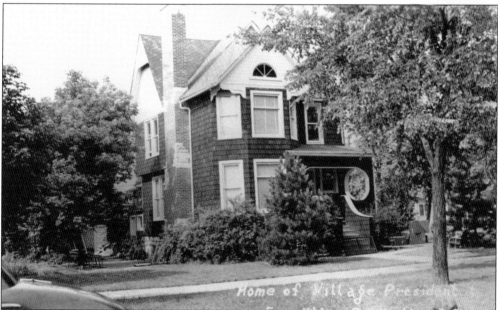

After serving a short term as a village trustee in 1932, Reeves was elected to the position of village president and served in that capacity for the subsequent 16 years. Having been elected during the heart of the Great Depression, Reeves's administration faced many challenges while attempting to keep the town solvent. The Reeves home, shown here at 9506 Schiller Boulevard, was eventually covered with a coat of cement and remains standing today.

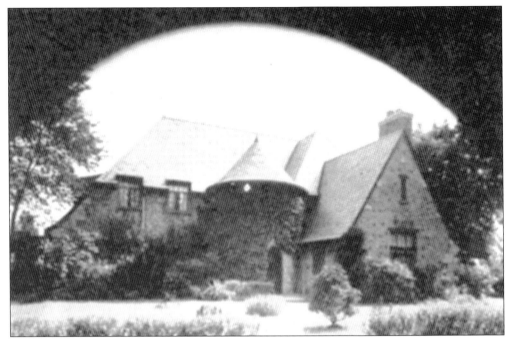

This beautiful residence located at the southeast corner of Atlantic Street and Schiller Boulevard was the home of Charles E. McAvin. McAvin operated a funeral parlor business from his home. The building was torn down in the 1960s.

The McNerney family settled in River Grove, Illinois, during the 1800s. Owen McNerney was River Grove's village president from 1903 to 1906. His son, William McNerney, served in the United States Army during World War I. Shown here on the right end of the threesome, wearing a River Grove Nationals baseball uniform, William was accepted onto the Chicago White Sox baseball team after trying out. Unfortunately, a previously undiscovered heart condition preempted a professional baseball career for him.

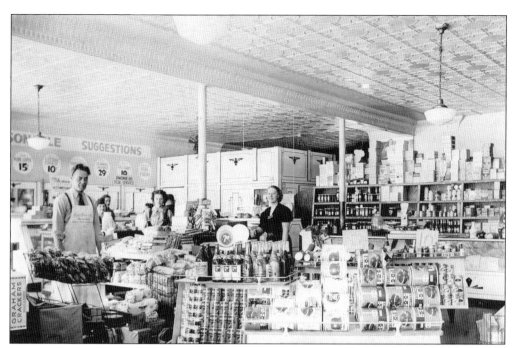

Nick Ricci and Elsie Ricci (née Fox), pictured here, built a four-store building on Franklin Avenue in 1928. In the photograph above, Charles Fox is shown helping a customer, Mrs. Puglia, with assistance from his sisters, Edith and Elsie Fox, inside the Royal Blue Grocery Store, an establishment that sold foods in bulk before self-service became the standard. The store later became a Certified Grocery. The Riccis' old building has housed numerous tenants throughout the years, including the Franklin Park Post Office, Sax-Tiedemann Funeral Home, the Hub Gift Store, and several doctors' offices, insurance agents' offices, and employment offices. The Great Depression, beginning in 1929, forced Nick Ricci to operate an additional plumbing business out of his building so that he could avoid losing it. His plumbing venture remained successful for many years.

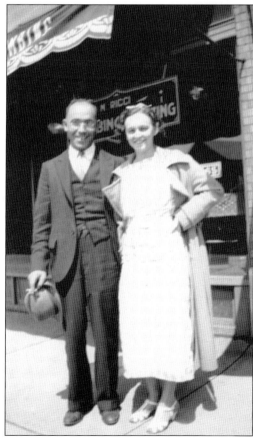

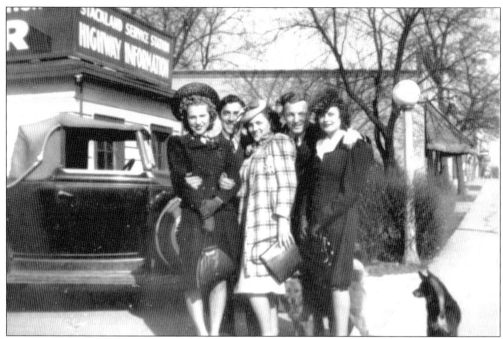

Jack Stackland expanded his business on Franklin Avenue in 1926, when he built this early Sinclair service station next door at 9722 Franklin Avenue. Pictured here standing in front of a roadster beneath a sign advertising highway information are, from left to right, Millie Fox, Andrew Bartolini, Annette Dustin, James Krisby, and a third unidentified lady dressed in fashionable garb.

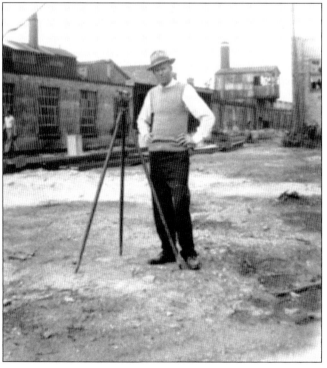

Daniel Bertram Nelson, born in 1900, came to Franklin Park in 1935. He is shown here surveying the property of the abandoned complex that he purchased for back taxes. Extensive renovations were required to make the complex suitable for steel processing. By 1939, Nelson Steel and Wire Company was in operation. The company contributed needed war materials a couple of years later.

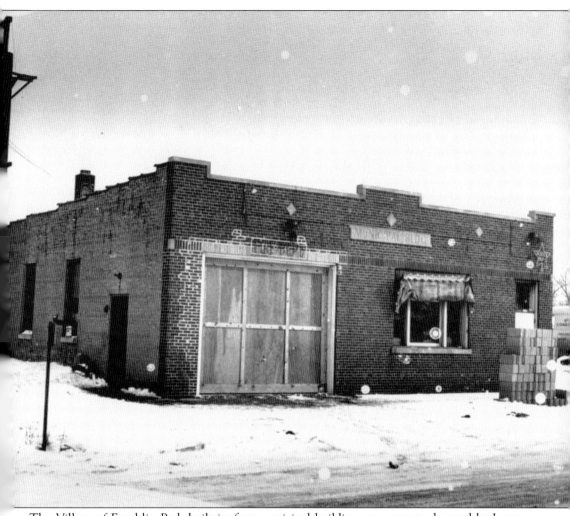

The Village of Franklin Park built its first municipal building on property donated by Lesser Franklin. The building housed offices, the fire department, the police department, and even the village's library. It was modified and added to several times during the years that it stood. On August 9, 1929, officials were startled when plaster began to fall from above at a village board meeting. A subsequent evaluation revealed extensive structural defects of the building, resulting in its condemnation. Despite the ongoing depression, voters approved a $21,428 referendum to retire outstanding Franklin Park debts and an additional $5,000 for repairs and upgrades to the municipal building. Upon completion of the modifications in January 1931, a further cost of $648 was paid by the volunteer fire department, allowing Franklin Park staff, after holding board meetings at a number of temporary locations, to occupy the renovated building.

Rozzi's Place was located at the southwest corner of Hawthorne Street and Belmont Avenue. The restaurant and bar was a neighborhood favorite. Many modern-day residents still remember card games that took place in the basement of the building, accessed through a trapdoor positioned underneath the bar. From left to right, Adolph Bogacz, Harold Kater, and Joseph Warzel stand behind George and "Ma" Woods. Ma Woods and her daughter, Anna, were the cooks, well known for their pork chops and hamburgers. Italian residents who moved to Franklin Park after 1900 spent time playing bocce ball on the lawn in the parkway. A fire ignited one evening, resulting in the loss of this neighborhood gathering place. The corner where Rozzi's Place once stood is now occupied by Hawthorne Park.

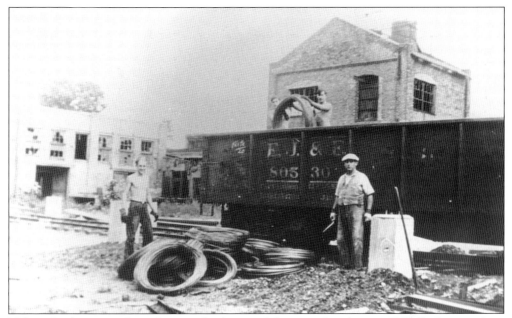

Nelson Steel personnel are shown unloading steel from a railroad car in 1939. Broken windows peer down at them from abandoned foundry buildings in need of repair. Several buildings that were constructed by the original foundry company have been utilized by different companies during the last 65 years, a few of which include Belmont, National Concrete Pipe, Hellstrom, and Scot Forge. Bar stock and coiled steel, the material visible in this photograph, are unwound, cut, cleaned, and processed into specific lengths and diameters. This is accomplished by drawing the material through machinery with a pulling force of 75,000 pounds.

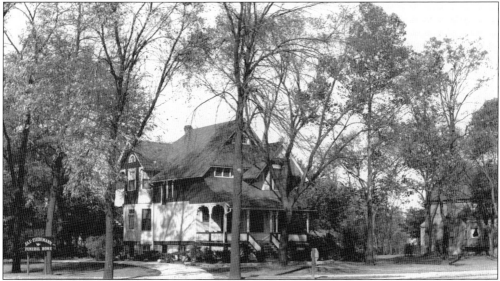

The oldest business in Franklin Park that originated in town is Sax-Tiedemann Funeral Home. It was founded by Maurice Sax and Peter Thomas Tiedemann in 1924. It was originally located on Franklin Avenue, where it coupled as an undertaking parlor and furniture store, a common business combination during that era. In 1937, Tiedemann and his wife, Irma, moved the business to its current location, shown here at Rose Street and Belmont Avenue.

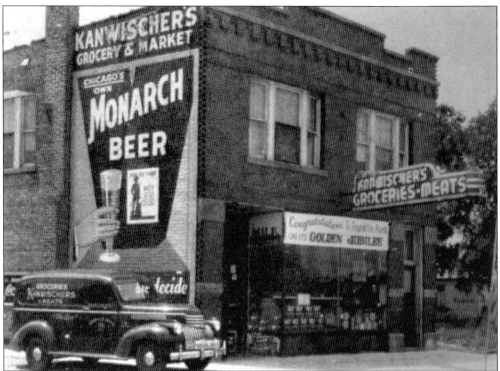

In 1935, Ray Kanwischer's milk store was located approximately where the Franklin Park Community Center stands today. After expanding into a full grocery and meat market, Kanwischer moved his business to this two-story brick building, one block west on Franklin Avenue, near Gustav Street. J. H. Dart had it built in 1914 to house a modern market with an apartment on the second floor. Today the building is occupied by a printing business.

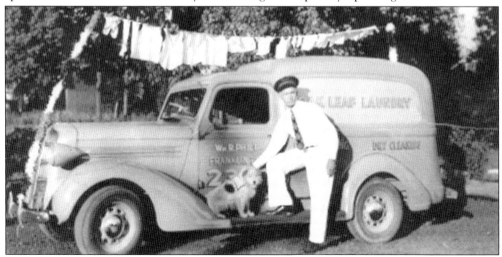

William Philip stands alongside his truck at 2828 Birch Street on a block that is occupied primarily by industrial buildings today. Philip worked out of his home, providing laundry and dry-cleaning pickup services to other residents. His company's name was Oak Leaf Laundry. Although Philip operated his business from home, the actual cleaning was performed at area commercial laundries including Westwood, Suburban Home Cleaners, and Enger Brothers.

Five

WORLD WAR II AND THE POSTWAR ERA

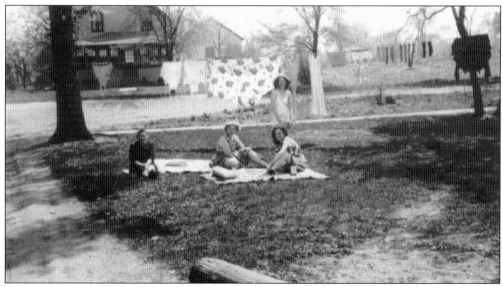

On a hot summer day, six months before the United States entered World War II in 1941, Elizabeth Hilder, Colattia Smith, Jo Misker, and Corrine Smith (standing), from left to right, sunbathed in front of the house at 3002 Willow Street. A house and barn across the street at 9205 Park Lane Avenue were the only other buildings on the block. The house still stands today, but the remainder of the block is now comprised of small factories and apartment buildings.

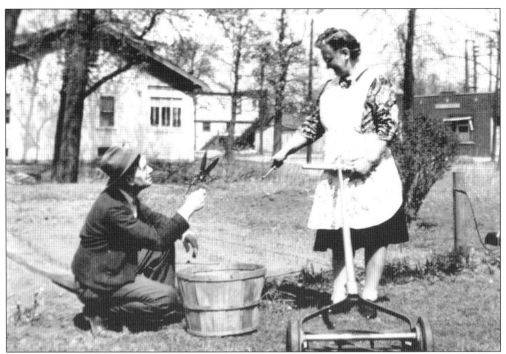

Vernon Reed tends his garden as his wife, Lydia, mows the grass with a then-popular reel mower at 3108 Atlantic Street. Several houses were later built on the site of Reed's garden, extending north to the house visible in the background. The earliest village hall building and firehouse is pictured across the street in the photograph.

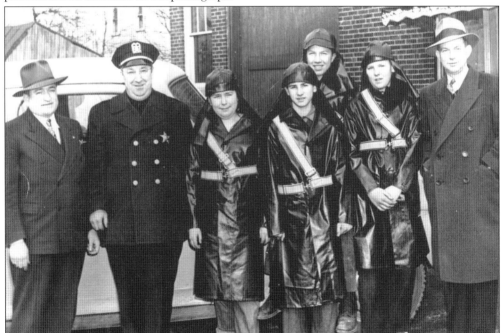

Local merchant Ray Kanwisher, police chief Andy Betts, and Mayor Barney Reeves stand in front of the Atlantic Street municipal building with school-crossing patrol boys between them.

Highway Bus Lines

EFFECTIVE SEPTEMBER 13, 1943
LEAVE END OF IRVING PARK
CAR LINE

TO DOUGLAS PLANT

6:10 A.	12:40 P.	7:10 P.
6:40 A.	1:10 P.	7:40 P.
7:00 A.*	1:40 P.	8:10 P.
7:10 A.	2:10 P.	8:40 P.
7:35 A.	2:40 P.	9:10 P.
8:10 A.	3:10 P.	9:40 P.
8:40 A.	3:40 P.	10:10 P.
9:10 A.	4:00 P.*	10:40 P.
9:40 A.	4:10 P.	11:10 P.
10:10 A.	4:40 P.	11:40 P.
10:40 A.	5:10 P.	12:10 A.
11:10 A.	5:40 P.	12:30 A.
11:40 A.	6:10 P.	
12:10 P.	6:40 P.	

* Except Sun and Hol.

EXTRA BUSES AT SHIFT CHANGES
Quickest, Most Direct Route for

CHICAGO WORKERS

Living 5000 No. to Anywhere South

20 Minutes to Plant - Fare 10c

At the outbreak of World War II, the federal government implemented the Emergency Plant Facilities Program. Douglas Aircraft Company built several plants, including a two-million-square-foot factory located immediately north of Franklin Park in the small community then known as Orchard Place. This factory, which later became known as Orchard Place/Douglas Field, was chosen by the company because of its proximity to extensive rail facilities and because of the abundant labor force in the growing Chicago and suburban metropolitan area. This bus schedule from 1943 shows the numerous busses that were available on the Irving Park Road line. (Courtesy of Len Duszlak.)

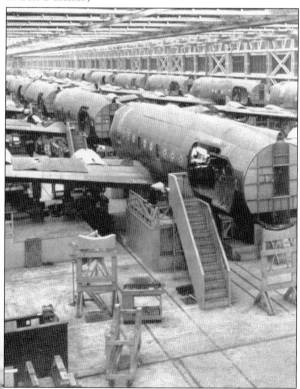

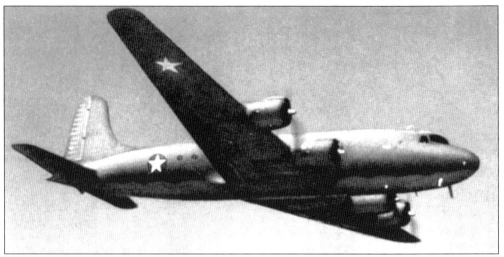

Douglas Aircraft, working in conjunction with the Corps of Army Engineers, the Chicago Association of Commerce, and the Civil Aeronautics Authority, chose rural Orchard Place in part because of the potential for a Japanese air strike on a West Coast facility. It was here that the company built four engine C-54 Skymaster cargo planes. At the conclusion of World War II, the City of Chicago took over the facility. The International Air Transport Association code ORD remains today, despite the renaming of the airport to O'Hare International in 1949. (Courtesy of Len Duszlak.)

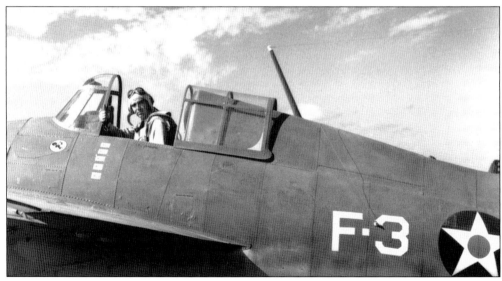

Orchard Field was renamed O'Hare International Airport in 1949 to honor Lt. Comdr. Edward "Butch" O'Hare, a naval fighter pilot from Chicago who was killed in World War II. On February 20, 1942, he downed nine enemy aircraft while defending the aircraft carrier *Lexington*. Pres. Franklin Delano Roosevelt awarded O'Hare the Congressional Medal of Honor for this feat. One year later, he earned the Distinguished Flying Cross Award. On November 26, 1943, O'Hare and his F4F-3 wildcat were lost in battle near Tarawa.

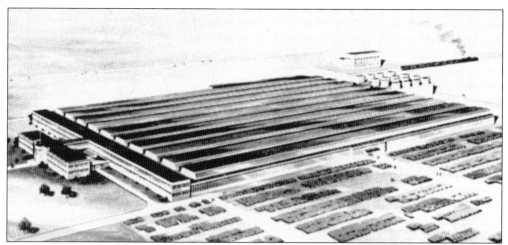

One national defense project that had a profound impact on Franklin Park was the $31 million aviation motor plant constructed at North Avenue and Mannheim Road. Originally the Elmer Galnex farm, this 125-acre tract of land had become the Nor-Man Airport in 1930. The aviation engine plant, Buick Motors division of the General Motors Corporation, produced 1,200-horsepower Pratt-Whitney radial, air-cooled airplane engines ready for installation at a rate of 500 per month. The plant employed 10,000 people, including 4,000 boys of high school age, who were there for mechanical training, altogether providing an annual payroll of $17 million.

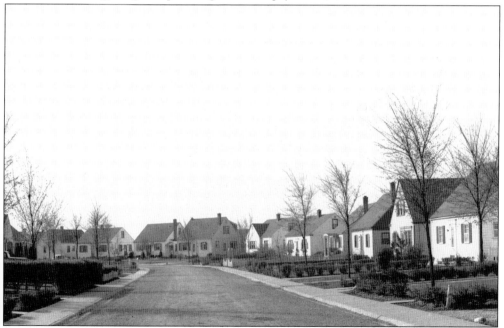

A Chicago realtor who spent his winters in Beverly Hills became intrigued with a housing development called Westwood that featured unconventional winding streets. In 1940, Lawrence H. Mills purchased 85.75 acres between Grand and Fullerton Avenues in Franklin Park. The plotting of 415 homes inside this area coincided with construction of the Buick Motors division aviation engine plant a half-mile away. The new neighborhood was named Westbrook and was characterized by unique winding streets, one of which was named Westbrook Drive. Ironically, this particular street lies to the east side of the brook.

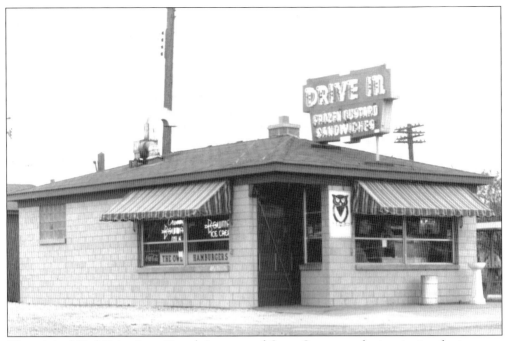

The original Owl Drive-In at Grand Avenue and Scott Street got the inspiration for its name from the symbol for the Westbrook Homeowners' Association—WHO. The popular eatery was famous for its frozen custard and hamburgers. Patrons often purchased dairy specialties at a walk-up window. A larger building that still stands today replaced the one shown here. The owl monogram can still be seen on the sidewalk at the entrance of the restaurant that now occupies the building.

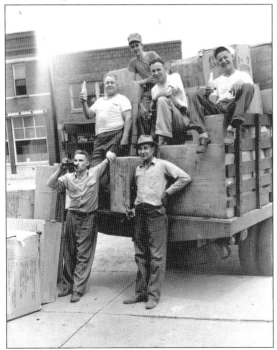

The description "Clothing For War Relief From Procurement Div. Treasury Dept. By Franklin Park" is stenciled on the cardboard boxes being loaded onto the back of a truck in this photograph. This scene took place on Franklin Avenue in 1945. Wade Steel, the man with the hat on standing behind the truck, had taught at Leyden High School for more than 15 years before he was promoted to assistant principal that same year.

Farver Drug Store opened for business in 1934. The store was located inside the old bank building at 9700 Franklin Avenue. A fire that took place in 1941 required owner Brook Farver to completely remodel. The refurbished store featured a complete soda fountain and beauty bar. An addition was made to the west side in the 1950s. A family restaurant occupies this building today.

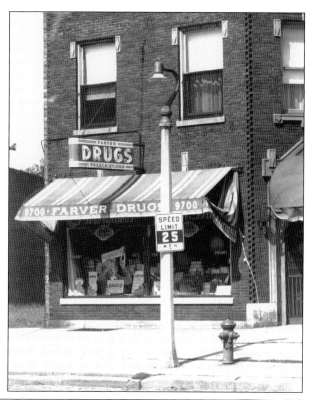

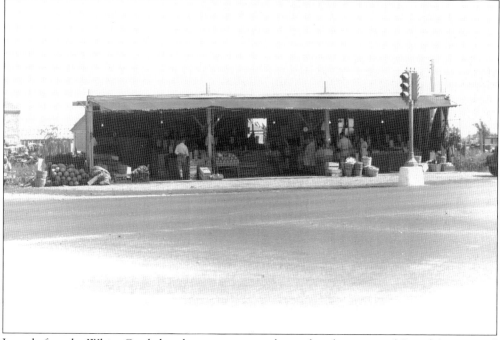

Long before the White Castle hamburger restaurant located at the corner of Grand Avenue and Mannheim Road opened its doors, this fruit and vegetable stand occupied the southeast corner of this intersection.

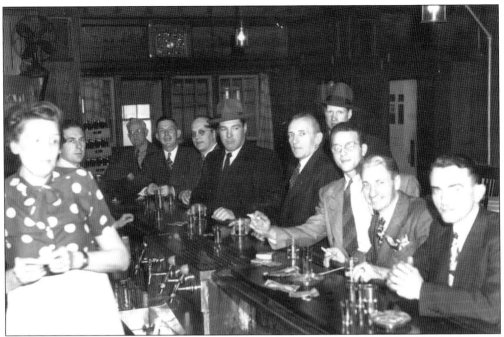

Mayor Barney Reeves and other village officials are shown seated at the bar inside the Orchard Bungalow at Franklin Avenue and Ernst Street.

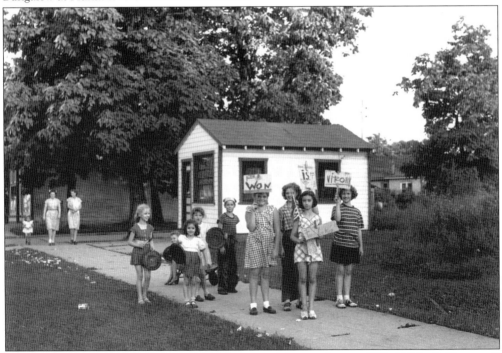

Smiling children take part in the local celebration of the conclusion of World War II. The small building in the background served as a real estate office on Franklin Avenue for 50 years or more. It was moved from Gustav Street and Franklin Avenue a couple of times, eventually ending up at Atlantic Street and Franklin Avenue. This was its final location prior to demolition.

Axel Lonnquist was born in Stockholm, Sweden, on August 16, 1881. In 1925, he purchased the farms of Fred Schaffer and Henry Menshing in Mount Prospect. Lonnquist then designed a luxury community, incorporating the proximity of his land to Weller Creek and to trains, and coordinating services within the community. He built the Northwest Hills Country Club as the centerpiece of his development, with membership tied to the ownership of a lot. When the Great Depression hit later, it became very difficult for Lonnquist to sell his luxury lots. By 1931, he sold the property. Lonnquist would begin a new development in Franklin Park a little more than 10 years later.

Larger size Homes under construction on Wagner Boulevard

The modern homes in Lonnquist's new development included features such as full concrete basements, automatic gas water heaters, and coal rooms. For 20 years, coal delivery trucks were often seen on the streets of the Lonnquist subdivision. Boasting in their sales brochures that "No house can ever have water backing up into the basement in our project," this claim proved untrue as basement flooding did occur frequently. Extensive sewer construction took place 40 years later, greatly eliminating the common threat.

Al Farver and his wife are shown standing in front of their airplane at Mitchell Field in Lombard, Illinois. Farver opened a television and radio repair business at 3148 Calwagner Street after completing construction of the store and an apartment in 1946. Several other small airports were located in the general vicinity of Franklin Park, including Sky Haven, Fairview, Checkerboard, Nor-man, and Skyline.

Timothy B. Reeves became the pastor of Franklin Park's Methodist church in 1946. The end of World War II brought tremendous growth to the village, with its population of 3,007 in 1940 growing to 18,322 by 1960. Reeves aided his church with its expansion by encouraging the congregation to purchase a block of lots on Schiller Boulevard in 1949. Often seen in the company of Fr. Donald Ahern from St. Gertrude's Catholic Church, the two religious leaders actively called upon families that were just arriving to Franklin Park, increasing their churches' membership rolls.

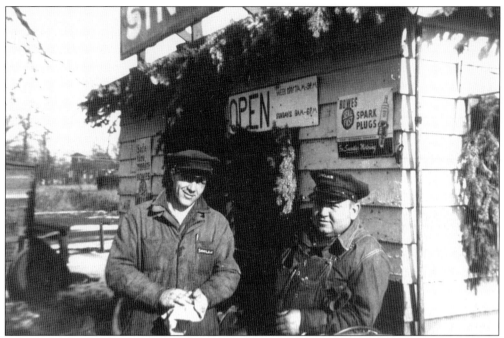

Earl Lund and Orville Lang eventually became proprietors of the Sinclair station on the west end of the Franklin Avenue shopping area. The station is shown here decorated for the Christmas season with evergreens. The Langs later had a new station built by the Latoria brothers. It was located at the triangle west of Ruby Street between Franklin and Belmont Avenues.

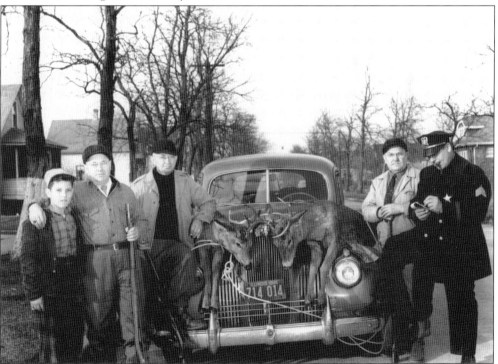

Police chief Andy Betts hams it up with local residents after a successful hunting trip in 1945.

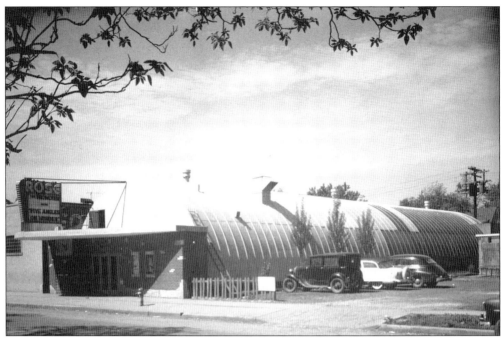

The Rose Theatre opened on December 23, 1948, inside a World War II Quonset hut with a new front entryway made of brick. Billed as the "Theatre of Tomorrow," the Rose Theatre was strongly supported by the local chamber of commerce and by Franklin Avenue merchants. It was believed that the new theater would attract potential customers to downtown Franklin Park, thereby promoting them to shop in this area. Samples of the theater's seats and related items were displayed in store windows to advertise the grand opening. Mayor McNerney (back left) and police chief Bondlow stand behind a group of children near the popcorn and candy counter in this photograph. For 25¢ per patron, the Rose Theatre offered Saturday matinees that included two feature films and a cartoon.

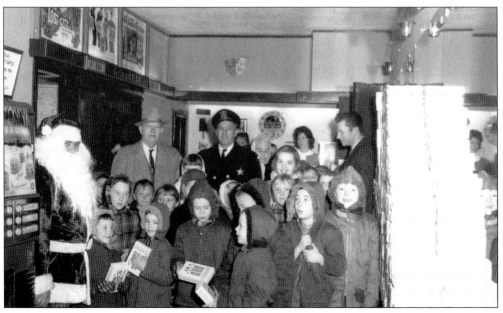

Arthur E. J. Ryberg, the son of two Swedish immigrants, moved to the Franklin Park area from Bridgewater, Connecticut, with his wife, Barbara Cornet, in 1937. While studying at the Moody Bible Institute, Ryberg supported his family by working in building construction. He helped build Rhodes School, the River Grove Bible Church, and several homes in the area. A chronic infection of the leg caused by a motorcycle accident resulted in amputation, forcing Ryberg out of the construction business. He then purchased the Franklin Park Coal and Material property on Chestnut Street and began producing concrete for the developing community.

Ryberg purchased a material yard adjacent to the railroad tracks on Chestnut Street in 1952. The property served as a reliable source of concrete for many local artisans, including the two pictured here with Ryberg behind his office, Walter Larsen to his left and Ed Terpstra to his right. Ryberg's religious training enabled him to preach on Sunday evenings at various missions in Chicago. Even after losing his sight in one eye, Ryberg continued to run Franklin Park Building Material until he passed away on February 16, 1987.

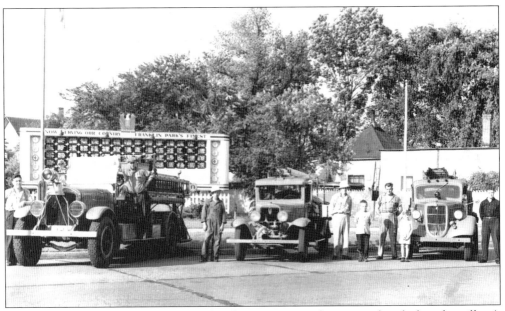

Members of Franklin Park's volunteer fire department are shown standing before the village's military memorial during World War II. Standing across the photograph are, from left to right, Glen Jensen, Clarence Schultz, John Talaga, Edward Goblin, Bill Sherry, Clarence Cherry, Bud Cherry, and Walter Hartley. The 1927 Pirsch fire truck on the far left was purchased brand new and remains in Franklin Park today, housed inside the fire museum on Atlantic Street and Franklin Avenue.

Post–World War II scenes like this one reflect some of the material shortages that were prevalent at this time in history. The use of older automobiles and restraints on housing construction due to the rationing of steel and copper fostered ingenuity in Franklin Park's growing community.

Six

THE LAST 55 YEARS

Rodger Hammill was born on August 30, 1915, at 2717 Clybourn Street in Chicago, the same house that his mother was born in. In his youth, Hammill followed the old "Indian Boundary Line" west to the Des Plaines River, searching for arrowheads in the woods along the way. In 1940, he married his girlfriend of 10 years, Dorothy. The couple moved to Franklin Park in 1942. Hammill's first studio was opened on Franklin Avenue in 1947. A camera that had been given to him by Dorothy on his 18th birthday became the tool that he used during his 60-year career, as he took thousands of pictures in Franklin Park and its surrounding areas. More than 10,000 pictures are now on file at the Franklin Park Library, including family portraits, police photographs, and photographs of school and club outings, village-sponsored events, and accidents.

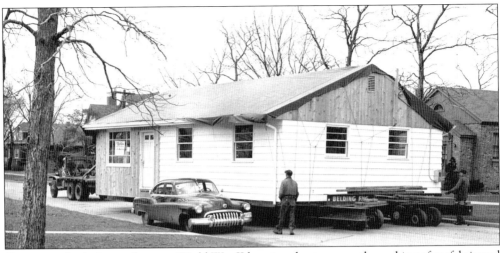

One unusual solution to the post–World War II housing shortage was the making of prefabricated houses in the Mobile Home Division of the Chicago Steel Corporation. The production facility at 9381 Schiller Boulevard could complete an entire home in 30 days. A model home at 9657 Pacific Street displayed many modern features for that time. After their completions, the houses were moved to different locations around town as shown here. Four of them still stand today within the 2800 block of Hawthorne Street.

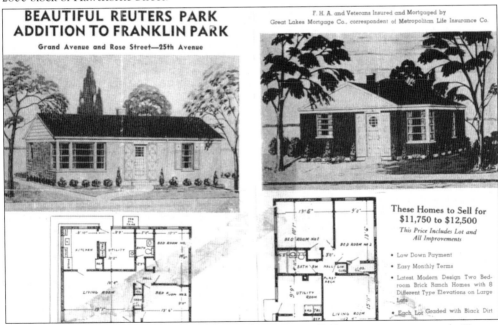

Leo C. Reuter of Wilmette, Illinois, unveiled his plans to erect 184 homes on approximately 40 acres of the former Popp and Herff farm on October 21, 1949. The Village of Franklin Park approved only 53 of the homes initially. Reuter Home Builders Incorporated then completed an annexation petition with Leyden Township, since the Franklin Park boundary extended just 600 feet south of Grand Avenue at that time. Reuter owned a bakery in the Montclare neighborhood of Chicago for 22 years prior to this, and his brother also owned one at 9657 Franklin Avenue. The proposed homes were to have many features, including solid brick walls, oak floors, forced air heat, and fully improved lots and streets.

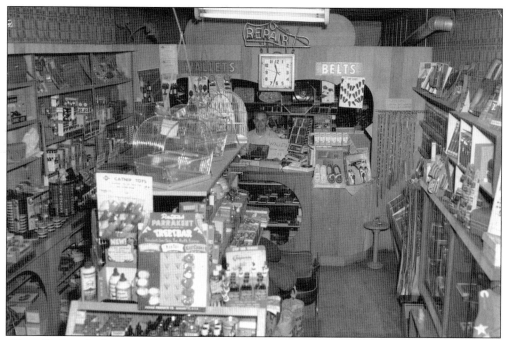

Albert DeAngelo, born in Abruzzi, Italy, in 1913, came to Chicago with his family at age three. When his father died in a bicycling accident nine years later, DeAngelo quit school and eventually ended up opening a shoe repair shop at the intersection of Laramie Avenue and Division Street in the city. After serving in World War II, he rented a store at 9658 Franklin Avenue where he repaired shoes and sold pet supplies. In 1971, the chamber of commerce purchased the property and razed DeAngelo's store to make room for a parking lot. Al's Shoe Repair relocated to 3039 Rose Street, where it remained in business until 2004.

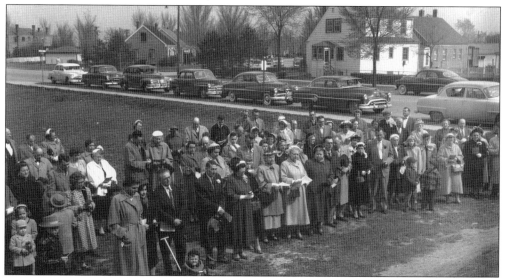

Resurrection Lutheran Church was organized in 1944. Services were initially conducted in the basement of one of the church's members, Richard Wimmermark. The ceremony pictured here preceded construction of the sanctuary on Grand Avenue between Elder Lane and Hawthorne Street.

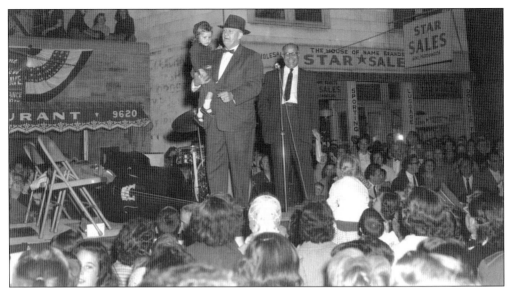

William (Bill) McNerney, holding a toddler on Franklin Avenue, began his political career as a village trustee in 1928. Elected village president in 1949, he witnessed the town's tremendous growth. McNerney oversaw the paving of all streets and the construction of the water tower, as Franklin Park became the third-largest industrial municipality in Illinois. A railroad employee by trade, McNerney once attempted to sell real estate, but soon quit stating, "I cannot sell a house to someone if I know the basement floods."

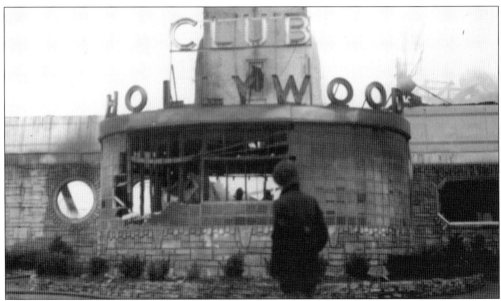

A defective neon sign was the source of the fire that destroyed this building on March 29, 1951. The horrific blaze caused $200,000 worth of damage. Club Hollywood, owned and operated by Olga and Steve Harris, had a seating capacity of 800 and featured two orchestras that gave three floor performances nightly. The popular entertainment venue, located at the northwest corner of Belmont Avenue and River Road, was reopened shortly after the fire. The reconstructed building was destroyed by another fire a little more than 10 years later on July 15, 1961.

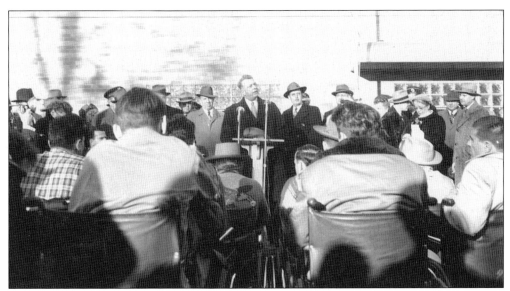

Sen. Everett Dirksen, speaking at the podium and flanked by reporters Rev. Timothy B. Reeves (immediately left of Dirksen) and Illinois state representative Margaret Stitt Church (standing inside the group) are shown here addressing the highly skilled employees of Paraplegics Manufacturing Company at 10068 Franklin Avenue. This company was incorporated on February 17, 1951, at Hines Hospital with Nils S. Josefson, a paraplegic veteran of the United States Navy, as its president. After World War II, many paraplegic and physically disabled veterans were employed at the specially designed facility that was equipped with wide doors and aisles and had benches built to accommodate operators in wheelchairs.

A rapid increase in Franklin Park's population found existing school facilities inadequate for housing new students during the late 1940s. Construction of two more schools was underway by 1951. The Methodist church at Calwagner and Gage Streets, also experiencing an increased membership rate, procured this old wooden schoolhouse previously located near O'Hare Field and had it moved to the rear of the church building. Used by the church for Sunday school classes, District 84 also used the schoolhouse to conduct classes in until North School was completed in 1952.

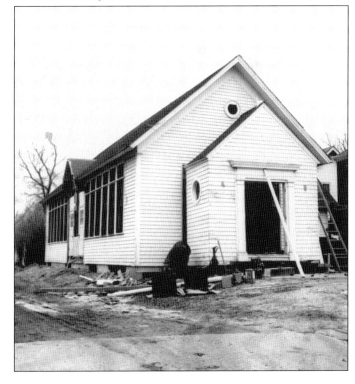

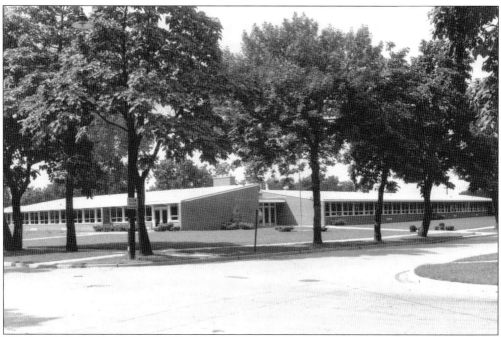

North and South (now Pietrini) Schools were finished in 1952. Six years later, additions were made to both schools, including gymnasiums, keeping them nearly identical. Superintendent Vance Hester was a strong advocate of neighborhood schools. He believed that children should be able to walk to and from school and go home for lunch. With the incorporation of five grade schools, this concept enabled District 84 to operate for many years without having a need for many buses.

The old railroad station and a troupe of baggage wagons are visible behind John Palmere, Edward Tillman, and Mayor William McNerney (from left to right) as the construction of a new parking lot for downtown merchants begins in 1954.

Frank Wilson and David Grant sit on a children's train at Grand Manor Kiddie Town. The park was operated dually with the Grand Manor Restaurant. Various amusements, including pony rides, made this a popular destination spot for kids. The round dome visible in the background is the restaurant, located at the northwest corner of Grand Avenue and Mannheim Road. Dave's Drive-In was later built at the site of the old amusement park.

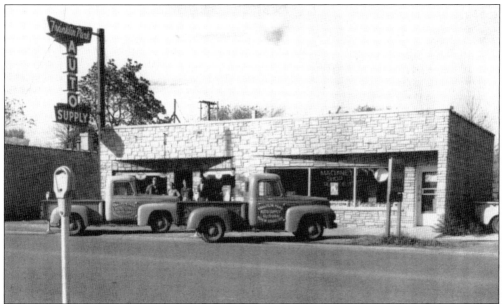

Edward Crispeels borrowed money from his father to join with William Kalter in opening Franklin Park Auto Supply on Franklin Avenue after World War II. In 1952, the business partners opened a new store at 9514 Grand Avenue. An addition was made to the building shortly after to accommodate a machine shop for engine, clutch, and brake work. Notice the parking meters alongside the two lanes of Grand Avenue in this 1958 photograph.

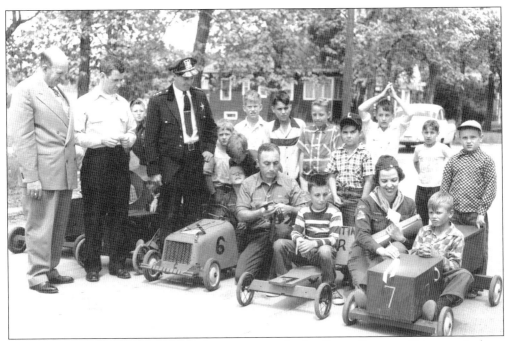

At this Boy Scout–sponsored "box car" contest, scout leaders Stuart Bauer and Margaret Jackson are shown attaching ribbons to the homemade creations. The judges overseeing the contest are, from left to right, Rev. Timothy B. Reeves, Fr. Donald Ahern, and police chief Ray Bondlow.

"Mankind was never so busily engaged as when it made a cathedral" is a statement once made by Robert Louis Stevenson. Nearly 63 years to the date of when the First United Methodist Church of Franklin Park was organized, the first half of its present-day sanctuary was consecrated on April 24, 1954. The estimated cost of the church's new building was $275,000. After $135,000 was raised, the portion of the building at Emerson Street and Schiller Boulevard that contains the church's school, offices, and fellowship hall was built. Construction of the actual sanctuary ensued eight years later.

Kiwanis Club of Franklin Park-Evening

Proudly presents to the

United Methodist Women

*This plaque in recognition and appreciation
for the many years of serving Kiwanis Club weekly meeting dinners
at the United Methodist Church.*

Behind every successful men's group is a women's organization backing it up. From the beginning in 1929, the women of the United Methodist Church supported the Franklin Park Kiwanis Club. For 56 years, ladies from the church cooked delectable meals every Tuesday night. Although occasional grumbles were heard from Kiwanis Club members because they were not able to smoke or have cocktails (dinners were served inside the church building), they did enjoy slipping into the kitchen for extra helpings of dishes like pot roast, pork chops, chicken, meat loaf, and other home style selections. Sitting at the table in the photograph are, from front to back on the left side, Jean Young, Lorraine Egerton, Annabelle Hoffman, and Hilda Demetros, and from front to back on the right side, Helen Pritchett, Margaret Granger, and Wilma Bookless, all United Methodist women who cooked for members of the Kiwanis Club.

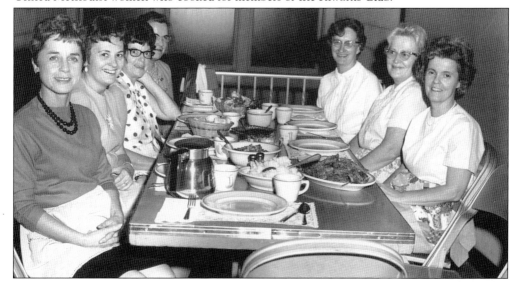

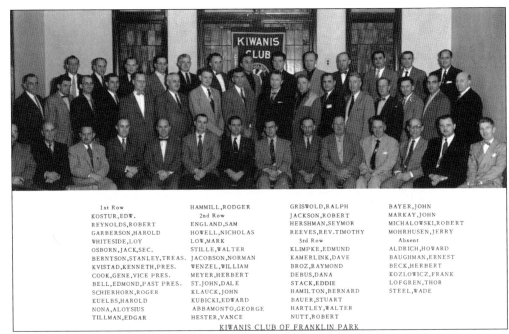

1st Row	HAMMILL,RODGER	GRISWOLD,RALPH	BAYER,JOHN
KOSTUR,EDW.	2nd Row	JACKSON,ROBERT	MARKAY,JOHN
REYNOLDS,ROBERT	ENGLAND,SAM	HERSHMAN,SEYMOR	MICHALOWSKI,ROBERT
GARBERSON,HAROLD	HOWELL,NICHOLAS	REEVES,REV.TIMOTHY	MOHRHUSEN,JERRY
WHITESIDE,LOY	LOW,MARK	3rd Row	Absent
OSBORN,JACK,SEC.	STILLE,WALTER	KLIMPKE,EDMUND	ALDRICH,HOWARD
BERNTSON,STANLEY,TREAS.	JACOBSON,NORMAN	KAMERLINK,DAVE	BAUGHMAN,ERNEST
KVISTAD,KENNETH,PRES.	WENZEL,WILLIAM	BROZ,RAYMOND	BECK,HERBERT
COOK,GENE,VICE PRES.	MEYER,HERBERT	DEBUS,DANA	KOZLOWICZ,FRANK
BELL,EDMOND,PAST PRES.	ST.JOHN,DALE	STACK,EDDIE	LOFGREN,THOR
SCHIERHORN,ROGER	KLAUCK,JOHN	HAMILTON,BERNARD	STEEL,WADE
KUELBS,HAROLD	KUBICKI,EDWARD	BAUER,STUART	
NONA,ALOYSIUS	ABBAMONTO,GEORGE	HARTLEY,WALTER	
TILLMAN,EDGAR	HESTER,VANCE	NUTT,ROBERT	

KIWANIS CLUB OF FRANKLIN PARK

Chartered on March 11, 1929, the Franklin Park Kiwanis Club has been one of the community's most philanthropic organizations. The club's generous fundraising activities, including Pancake Day and Peanut Day each fall, have enabled many programs for local children. Some of these programs include the Boy Scouts, the Girl Scouts, Little League, the Special Olympics, scholarships, eyeglass collections, and research for spastic paralysis. The membership of 1955 poses here at their evening meeting, held at the Methodist church at Calwagner and Gage Streets.

Easter egg hunts were held in the field at Leyden High School during the 1950s. The Franklin Park American Legion Post 974 sponsored the events. This photograph, taken in 1955, shows Mrs. Edward Zingraf addressing a small number of the nearly 2,000 children in attendance at one of the egg hunts. Eggs would be hidden under logs, benches, boxes, trees, and bushes. A few special eggs were adorned with the American Legion emblem, redeemable for prizes.

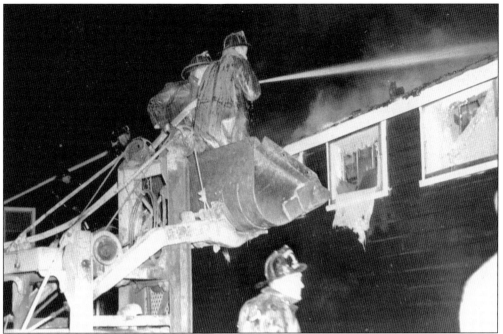

A mysterious fire that exploded on May 15, 1956, was ultimately found to be connected to the gruesome murders of Bobby Peterson and brothers John and Anton Schuessler. This photograph was taken of the fire at the Idle Hour riding stables, located at 8600 Higgins Road near Park Ridge, Illinois. Local photographer Rodger Hammill had taken photographs of the crime scene in the Robinson Woods Forest Preserve on October 16, 1955, and had also taken some of the subsequent fire at the stables. Hammill testified at the 1994 trial for the murders. His powerful photographs were submitted as evidence, contributing to the conviction of Kenneth Hansen, the man accused of the crimes.

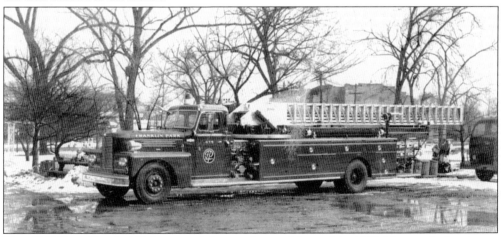

This 1961 Peter Pirsch 100-foot aerial fire truck was delivered in 1962. Not until after it was delivered did the fire department realize that it would not fit inside the Atlantic Street Fire Station. The truck was kept at Rodger Schierhorn Cartage's garage on River Road and Belmont Avenue. Whenever a need for the truck arose, a call was made and John Bono and Wally Warzel, both volunteer firemen and employees of Schierhorn, would bring the truck to the fire scene. Club Hollywood can be seen in the background of the photograph, behind the fire truck.

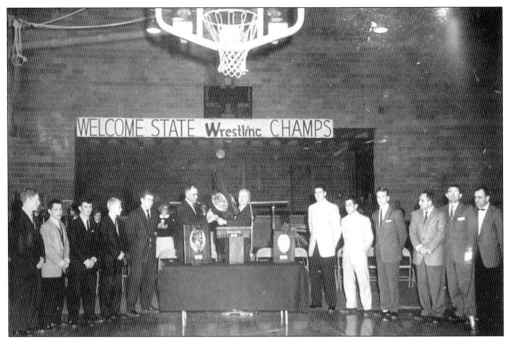

The team pictured here, which competed in hand-me-down basketball uniforms, won the state wrestling championship in 1960. Head coach Charles J. Farina (third from right), assistant coaches Richard Perry and Marty Schwartz, and the champion varsity team are shown being honored by Sam England and Orville Sayers inside the Leyden High School gymnasium. State champions in 1960 and 1978, Leyden High School's wrestling team also won 26 conference championships, 30 regional championships, 18 sectional championships, and had an undefeated dual meet streak of 88 consecutive victories between 1975 and 1979. Coach Farina passed away at age 75 on October 13, 2003.

Thomas Balk, postmaster from 1956 to 1977, is shown finishing his remarks at the groundbreaking ceremony for the first new post office built in Franklin Park. The Franklin Park Post Office had been housed inside stores at 9518, 9600, and 9712 Franklin Avenue for 68 years prior. The new building was completed in 1961. Its site at Franklin Avenue and Ruby Street had previously been used as a garage builder's display area. One of the model garages was moved one block north and sits beside the home at 9760 Pacific Street today.

Kenneth A. Kvistad (fifth from left), village president from 1961 to 1965, is shown here standing beside senatorial candidate Charles Percy (center). Under Kvistad's administration, the 24-inch water main from Chicago was built for $150,000. It was paid for without a bond issue. The first 50/50 sidewalk program was also launched while he was in office. Kvistad passed away on September 3, 2003, in Boynton Beach, Florida, after suffering complications from Parkinson's disease.

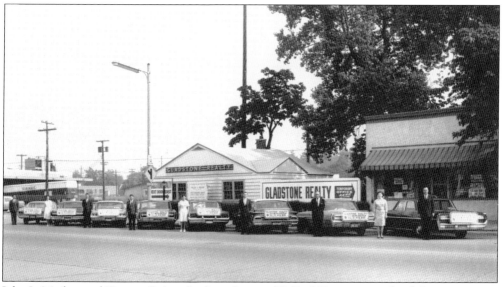

John L. Markay and Vincent Bolger, both graduates of DePaul University, utilized their training in business and law when they opened Gladstone Realty on July 13, 1954. Occupying a well-known gas station's old location at 9452 Belmont Avenue, the company soon became one of the most successful real estate agencies in the area. They introduced such business innovations as offering in-house sales training courses, using two-way radios, and displaying company advertisements on the vehicles of sales personnel.

O'Hare Stadium opened for its first race on June 17, 1956. Tom Croft won this race, a 25-lap event, driving a 1950 Mercury. The high-banked, quarter-mile, paved track was located north of Mannheim Bridge on property that is occupied by Northwest Ford and Sloan Valve Company today. It featured Nascar-sanctioned late model racing during 1960 and 1961. From 1962 to 1965, the American Racing Organization hosted an annual 500-lap event. Other events held at O'Hare Stadium included midget, Volkswagen, figure eight, and demolition races. The track was torn down after its final program on September 7, 1968.

Gene Marmor, shown here accepting a checkered flag and an O'Hare Stadium jacket from Art Kelly, was one of several popular stock car drivers from the area. By July 1963, Marmor's career record at O'Hare Stadium was 127 first place wins. Other drivers from that era included Fred Lorenzen, Bill Lutz, Roy Martinelli, and William "Whitey" Gerken. The bleachers full of fans in the background represent what a typical night was like during the track's 13-year history. Some residents still recall hearing the cars racing at night from their homes around town.

John Rumzis built this garage at the southwest corner of Edgington Street and Franklin Avenue. His daughter Eleanor married Sam Tuminaro, who took over the business and renamed it Sam's Towing. After outgrowing the building, Sam's Towing moved across the street into a larger facility. Joe and Wally Warzel then began to operate an automobile repair shop out of the old building, specializing in Diamond T truck repair and selling Cities Service petroleum products.

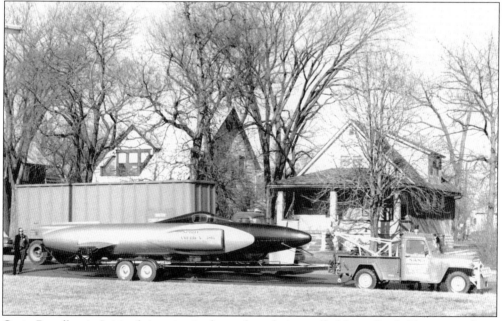

Craig Breedlove's *Spirit of America* is shown here being pulled by a Sam's Towing truck on Belmont Avenue. Powered by an ex-military jet engine from an F-86 Sabre, the three-wheeled machine set the land speed record at 526.277 miles per hour on October 15, 1964. At the end of the historic run, the *Spirit of America* broke its parachute, skidded five miles, and crashed into a brine pond at a speed of 200 miles per hour. After being restored, it was put on display at the Museum of Science and Industry in Chicago.

Shown here at the O'Hare Inn on Mannheim Road is 1964 presidential candidate Barry Goldwater (seated second from left), being flanked by two prominent Republican Illinois senators. Sen. Charles Percy (far left) was a World War II veteran who worked for Bell and Howell, eventually becoming chairman of the board. He served as an Illinois senator from 1967 to 1985. To Goldwater's immediate left is senate minority leader Everett McKinley Dirksen. A World War I veteran, Dirksen served as an Illinois Congressman from 1932 to 1946 and also served in the senate from 1950 until his death in 1969.

Howard and Charles Sostrin operated J&S Men's Wear at 9613 Franklin Avenue for several years. Many types of apparel were available at the store, including suits, work clothing, boots, and scouting uniforms. The Sostrins were active Franklin Avenue merchants, promoting special events like Sidewalk Sale Days.

Benjamin and Loraine Brzezinski sit in the backseat of a convertible in the parade that took place during the 1967 Diamond Jubilee, August 3-9. The Brezezinskis have lived in the same house on Ernst Street since they purchased it in 1953. Benjamin was elected village clerk in 1961 and then elected village president in 1965. In addition to helping coordinate the village's 75th birthday, Benjamin's support was also instrumental in the building of Franklin Park's second fire station at Scott and Addison Street.

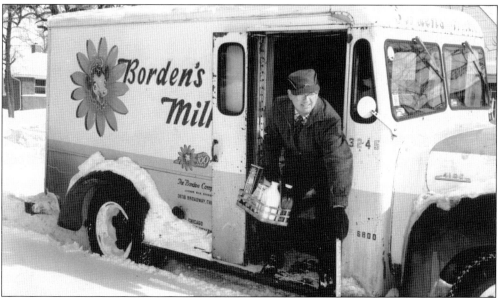

Elmer Steinmetz worked for the Borden Company for 35 years delivering milk, cream, butter, and other dairy items to locations throughout Franklin Park. Steinmetz's sons recall working for their father during the summers, carrying milk into houses and even placing it in families' refrigerators very early in the morning, a task possible because most people did not lock their doors at night then.

At 5:02 a.m. on January 26, 1967, a heavy snowfall began. The official total was 23 inches in 29 hours, but most areas of Franklin Park were covered with several feet of drifts within that time due to the 53-mile-per-hour winds. Stories are still told today of how police delivered medicine by snowmobile, grocery stores rationed bread and milk, and most people simply walked to their destinations for a few full days. This photograph was taken in front of Aggressive Hardware, looking east at the 9600 block of Franklin Avenue.

Franklin Park has always taken pride in the fact that its streets are consistently cleared of snow in a quick and timely manner. The record-breaking snowfall of January 26, 1967, required the village to bring in heavy equipment needed to remove moist, heavy accumulations in several areas including the downtown. Tom Tedei is pictured here atop a bulldozer in front of the Girbes Coal building at 9574 Franklin Avenue. Employees of the street and utilities department worked around the clock to clear the streets.

Railroad switch tower B-12 was moved from the intersecting railroads at Commerce Street and Franklin Avenue on November 11, 1996. Village trustees Richard Neuzil and Paul Bellendir (in front) and Mayor Daniel B. Pritchett (back left) escort Muehlfelt House Movers near Washington Street as the tower is moved to its new location beside the railroad tracks, west of Calwagner Street.

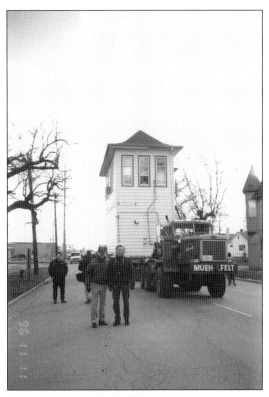

Shortly after the Japanese attack on Pearl Harbor, Richard T. Herrmann enlisted in the Army Air Corps. He was stationed in England for three and a half years, working as a B-17 mechanic. In 1946, he married his wife, Hildegarde (Hilde), and they bought a new home on Leyden Court. Herrmann owned and operated the Halsted Machine Shop in Chicago for 33 years. Joining the Franklin Park Kiwanis Club in 1970, he organized the Kiwanis Club Blood Replacement Program in 1974. It collected 13,000 units of blood within 20 years.

Greek immigrant John Angelos was born in Tripoli in 1894. At age 11, he came to America with $12 in his pocket and a promise from his uncle that he would meet him here. His uncle never showed up. Angelos persevered by shining shoes, delivering groceries, and learning English, all while sleeping in doorways. He opened his first store inside the old Franklin Park Hotel in 1943 and built a new Leyden Candy Shop at 3037 Rose Street seven years later. Angelos developed Lou Gehrig's disease at an old age. Upon his death, the entirety of his half-million-dollar estate was given to 52 of his relatives in Greece, all of whom he had never met. (Courtesy of Chicago Sun-Times; photograph by Bob Kotalik.)

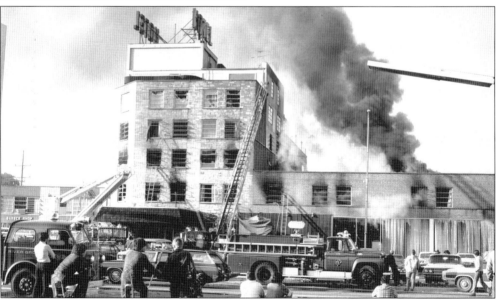

The fire shown here at the old Sunset Arms Hotel at Grand Avenue and Scott Street garnered the response of 12 area fire departments. The fire was set on June 30, 1973. Rubbish that had been left burning in a barrel on the second floor sent 15 guests and two firefighters to local hospitals, primarily for smoke inhalation. Fortunately, no one was seriously hurt. Approximately 45 minutes before the fire was reported, two mysterious unknown persons were spotted running down the fire escape from the second floor.

Congressman Henry Hyde (left), who served on the Illinois House of Representatives from 1966 to 1974, is shown here presenting an American flag to village president Jack B. Williams while speaking at the senior tower in Franklin Park. In 1972, Hyde became village attorney for Franklin Park and served in that capacity until 1982. In 1974, he was elected to the United States House of Representatives in the Sixth Congressional District, which included Franklin Park at that time. Congressman Hyde's 32-year-long career in government also included serving as chairman of the House International Relations Committee and House Judiciary Committee.

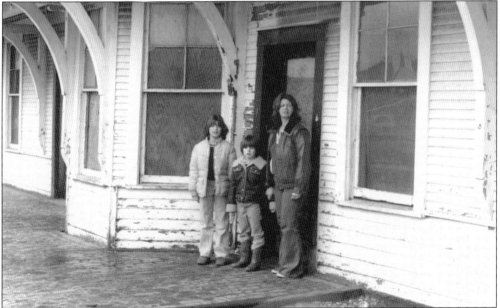

Standing in front of the once-elegant Franklin Park train station is Gail Pritchett with daughter Victoria and son Daniel on April 21, 1979. Originally built west of Calwagner Street by Lesser Franklin's instruction, the station was later moved east to its location near Rose Street, where it served the community for nearly 90 years. The boarded-up windows and peeling paint reflect the condition that the original building was in prior to its demolition on April 23, 1979.

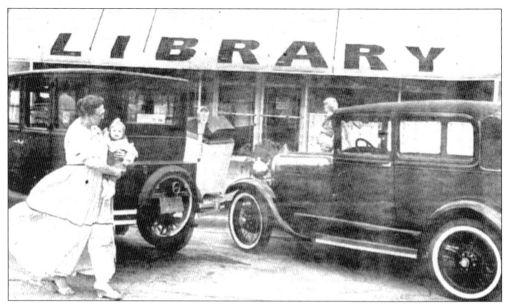

This 1982 photograph shows Louise Keuck carrying Amanda Pritchett in a recreation of Franklin Park's first election of 1892. In 1899, the Woman's Club of Franklin Park founded the library at 9602 Franklin Avenue. The post office and a general store shared the space. The library moved three times before it was brought inside a storefront at 9618 Franklin Avenue in 1964. It remained there for 20 years. On April 1, 1984, a beautiful new facility was dedicated at 10311 Grand Avenue.

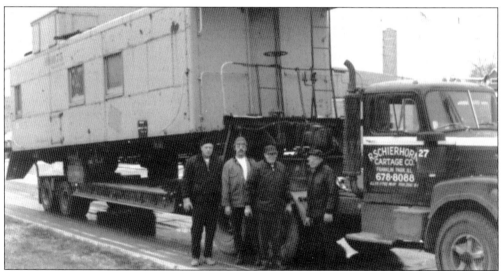

From left to right, Wally Dabrietz, John Bono Jr., Ernie Sietmann, and John Bono Sr., a village trustee and assistant fire chief, secured the caboose shown here onto a Roger Schierhorn cartage truck and lowboy trailer beside the railroad at Calwagner Street. In 1986, the caboose was unloaded alongside the Franklin Park Water Department's pumping station on Belmont Avenue. In 1999, it was moved across the tracks and placed beside the recently relocated and restored B-12 tower. Several individuals donated materials and labor for its restoration, including Bob Karner (Suburban Welding Manufacturing Company), Larry Maas (Carriage House Auto Body), and Mike Essenmacher.

William "Simms" Szymanski stands in front of the remaining walls of his building at 10360 Front Street after a fierce tornado hit on March 12, 1976. In addition to being a master toolmaker, Szymanski was a local historian who coauthored the *Historical and Architectural Guide to Old Franklin Park* and researched the actual burial site of Josette LaFramboise Beaubien on River Road.

The tornado that hit Franklin Park on March 12, 1976, began its destructive course at Cullerton Avenue, north of Grand Avenue. As it continued north, it damaged houses and factories on Belmont and Franklin Avenues, west of Mannheim Bridge, and then it moved east, destroying Electro-Mech Company on Front Street as shown in this photograph. One Commonwealth Edison employee was killed, and $15 million worth of damage was caused by the tornado described by witnesses as "a huge black cloud with three fingers aimed at the ground."

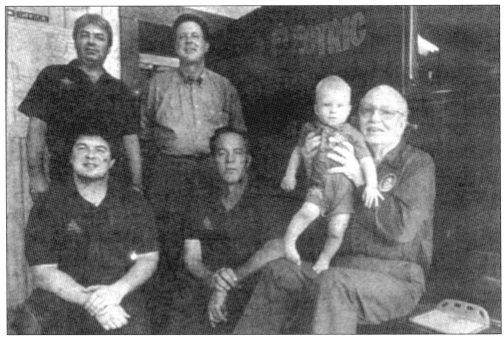

Omar Pritchett holds his great-grandson D. Bryce Pritchett, while sitting on the running board of his company's old truck. He is next to his sons, Michael Pritchett (kneeling) and Daniel B. Pritchett (standing), and beside them are Omar's grandson Daniel B. Pritchett Jr. (kneeling), and company employee Donald Tirlich (standing). This photograph represents three generations of Omar Electric owners and employees. The company has provided electrical installation to homes and industries in Franklin Park since 1949.

After 10 inches of rain fell on August 13, 1987, village officials were prompted to put a binding referendum for sewer improvements before the voters of Franklin Park. In March 1989, voters overwhelmingly approved the construction of three collection sewers traversing from Mannheim Road to the Des Plaines River, each averaging 120 inches in diameter and holding up to 50 million gallons of water. Mayor Jack B. Williams, with his foot propped on a shovel, is shown here surrounded by staff and elected officials at the connection to the deep tunnel at River Road.

Denver Broncos head coach Mike Shannahan grew up at 3333 Elder Lane in Franklin Park. He attended North School, Hester Junior High School, and East Leyden High School. He was voted "athlete of the year" in track and in football, once setting a Leyden High School record of 258 yards on 17 carries in a single game. While playing quarterback at Eastern Illinois University, Shannahan received a serious injury that cost him a kidney. This prevented the talented athlete from continuing to play his favorite sport, but it launched his coaching career. Now one of the most respected leaders in the National Football League, Shannahan was the first coach in history to win two Super Bowl titles in four years.

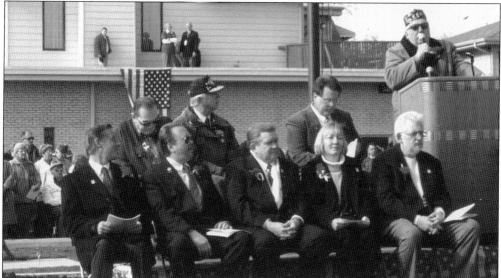

Herb Kasch, former American Legion commander and D-Day army veteran, speaks to an overflowing audience at the dedication of the veterans memorial on Veterans Day, November 11, 2000. The physical tribute to Franklin Park's veterans consists of five 10,000-pound monoliths inscribed with 1,352 names of past and present residents of the village, accompanied by two smaller monuments. Limestone boulders from the house that was formerly on the site surround the American flag and are accompanied by two artillery pieces that were acquired from the United States Army storage facility in Lexington, Kentucky.

From left to right, Daniel B. Pritchett, Larry Duke, Paul Bellendir, Chuck Vogelsang, and Paul Sharp stand in the basement built to support the relocated 120-year-old B-12 tower. Countless residents volunteered to help with the tower's renovation, offering both labor and materials for the project. The restored B-12 tower and the park surrounding it were both dedicated on May 20, 2000, at Franklin Park's annual Railroad Daze festival.

In 2002, a Metra locomotive was designated the "Village of Franklin Park." This popular railroad program has enabled many communities throughout the Chicagoland area to have their names affixed to Metra's passenger train engines. Amanda Pritchett is shown breaking a bottle of champagne with her father at Railroad Daze to celebrate.

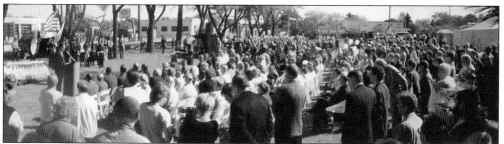

Village president Daniel B. Pritchett stands behind a podium as he addresses a crowd of several hundred people. This photograph was taken at the groundbreaking ceremony for the Grand Avenue Underpass on October 10, 2004. The underpass is a $43 million undertaking, and it took more than 50 years of efforts by the Village of Franklin Park to make it a reality. The single largest public works project to be undertaken in Franklin Park is scheduled for completion in 2007. (Courtesy of Francis A. Onorati.)

For more than 100 years, the Franklin Park Woman's Club has been involved in philanthropic and civic endeavors. In 1959, the club began legal proceedings to construct an underpass on Grand Avenue. This would bring much relief from traffic and railroad congestion in the area. From its beginning, this club has been active and respected in the community. In 1908, it influenced the construction of the village's first sewer. The Grand Avenue Underpass will be completed in 2007. Here members of the woman's club are accompanied by other women from the community at a celebration for the underpass. (Courtesy of Francis A. Onorati.)

SELECT BIBLIOGRAPHY

Centennial Commemorative Committee. *The History of Franklin Park, Illinois in Words And Pictures.* Franklin Park: Centennial Commemorative Committee, 1992.

Diamond Jubilee Committee. *Diamond Jubilee 75th Anniversary 1892-1967.* Franklin Park: Diamond Jubilee Committee, 1967.

Diamond Jubilee of Melrose Park. *Pictorial, Historical Review of Melrose Park, Illinois 1882-1940.* Melrose Park: Melrose Park Chamber of Commerce, 1940.

Edwards, Jim and Wynette. Images of America *Chicago City of Flight.* Chicago: Arcadia Publishing, 2003.

Fulbrook, Mary. *A Concise History of Germany.* New York: Cambridge University Press, 1990.

Golden Jubilee Committee. *50th Anniversary Village of Franklin Park 1892-1942.* Franklin Park: Golden Jubilee Committee, 1942.

Nock, O. S. *Encyclopedia of Railroads.* New York: Galahad Books, 1997.

O'Shea, Gene. *Unbridled Rage.* New York: Berkley Publishing Group, 2005.

Perry, Mary Elizabeth. *The Encyclopedia of Chicago.* Chicago: University of Chicago Press, 2004.

Schacht, Sylvia Nortens. *When River Grove Was Young 1888-1938.* Iowa City: Maecenas Press, distributed by Lincoln Hall Press, 1985.

INDEX

ACROSS AMERICA, PEOPLE ARE DISCOVERING
SOMETHING WONDERFUL. *THEIR HERITAGE.*

Arcadia Publishing is the leading local history publisher in the United States. With more than 3,000 titles in print and hundreds of new titles released every year, Arcadia has extensive specialized experience chronicling the history of communities and celebrating America's hidden stories, bringing to life the people, places, and events from the past. To discover the history of other communities across the nation, please visit:

www.arcadiapublishing.com

Customized search tools allow you to find regional history books about the town where you grew up, the cities where your friends and family live, the town where your parents met, or even that retirement spot you've been dreaming about.